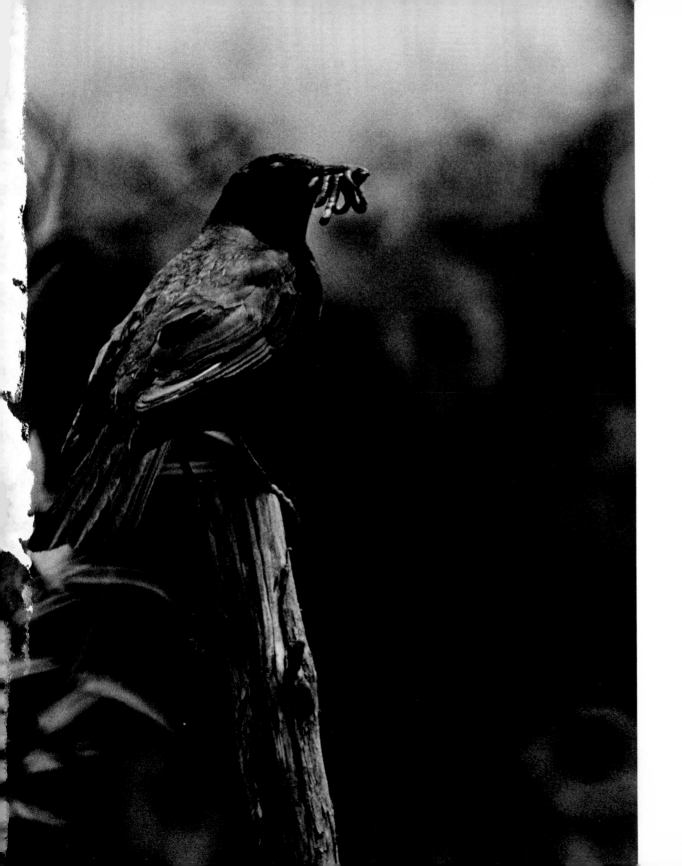

PASSPORT
TO
NATURE

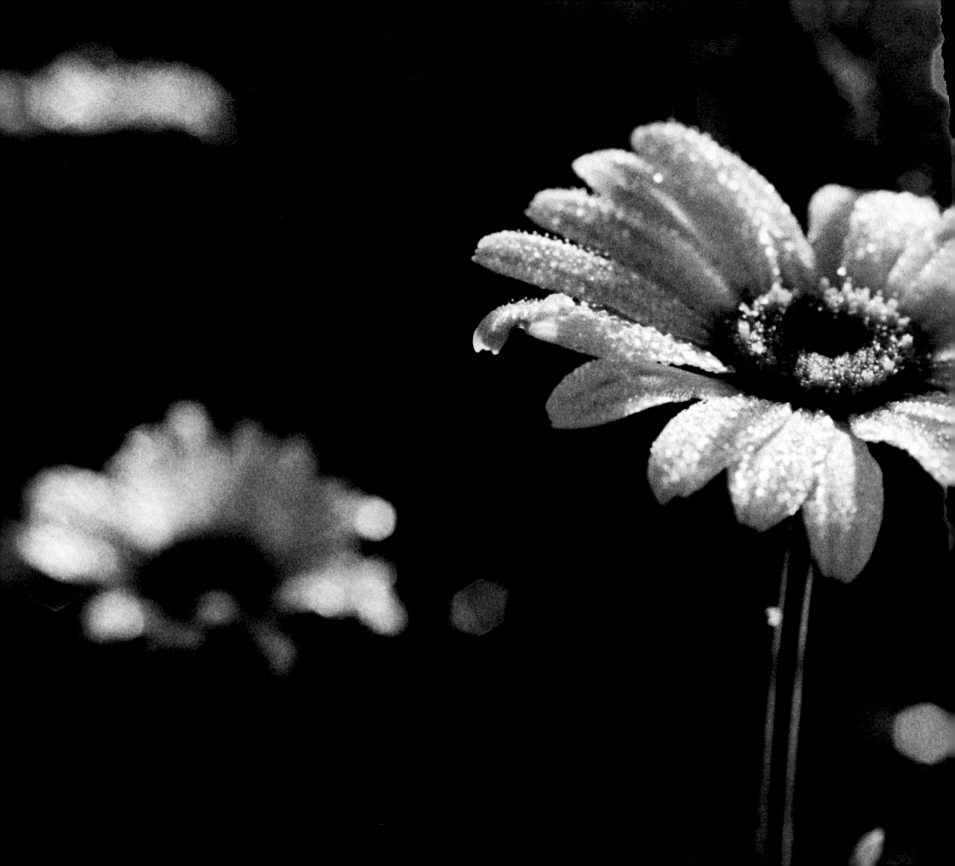

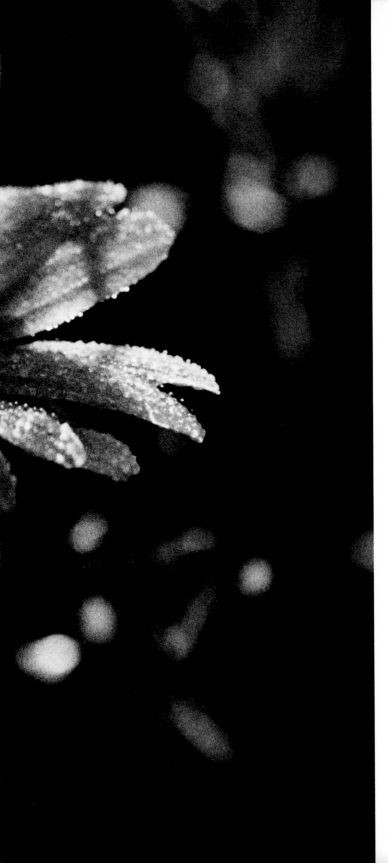

PASSPORT TO NATURE

William G. Damroth

Introduction by Arthur Godfrey

A Studio Book • New York • The Viking Press

ACKNOWLEDGMENTS

Thanks to the many people who have helped to make this book a reality . . .

 . . . to Norma Green, who gave me confidence to continue with my photography

 . . . to Ralph Baum, who introduced me to the professional world of photography

 . . . to Jorge Figueroa for his sensitive darkroom techniques

 . . . to Bill Ryan, who brought me to African wildlife

 . . . to Fred Kinsky, who introduced me to the birds of New Zealand

 . . . to Dick Casey, who patiently catalogued my 7000 negatives

 . . . and to Nicolas Ducrot, Mary Kopecky, and Tony Wolff for their creative efforts.

First published in 1972 by The Viking Press, Inc.
625 Madison Avenue, New York, N.Y. 10022

Published simultaneously in Canada by
The Macmillan Company of Canada Limited

SBN 670-54195-8

Library of Congress catalog card number: 77-178821

Printed in U.S.A. by Rapoport Printing Corp.
Bound by Montauk Book Manufacturing Co. Inc.

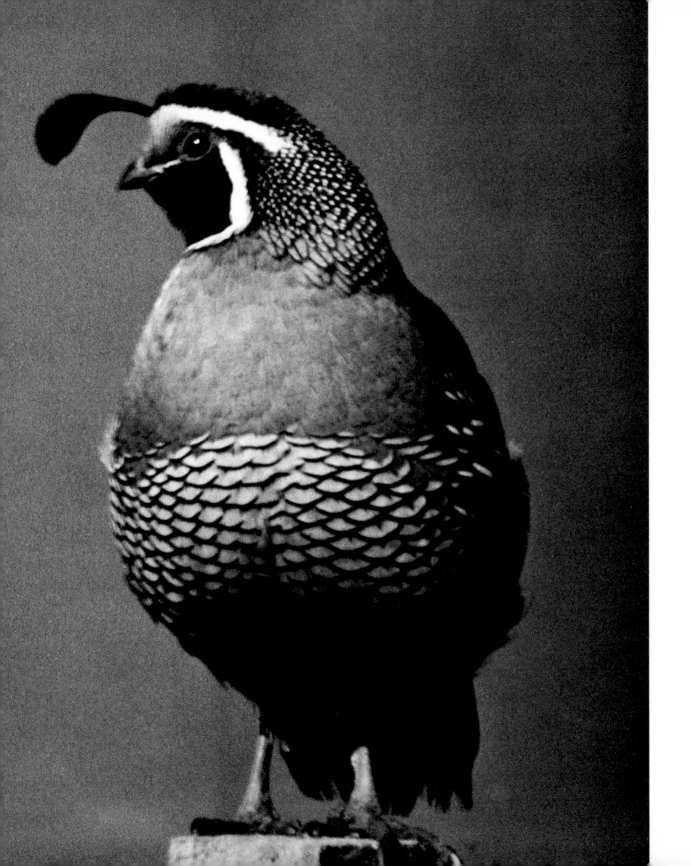

To My Sons
Peter
David
and
John

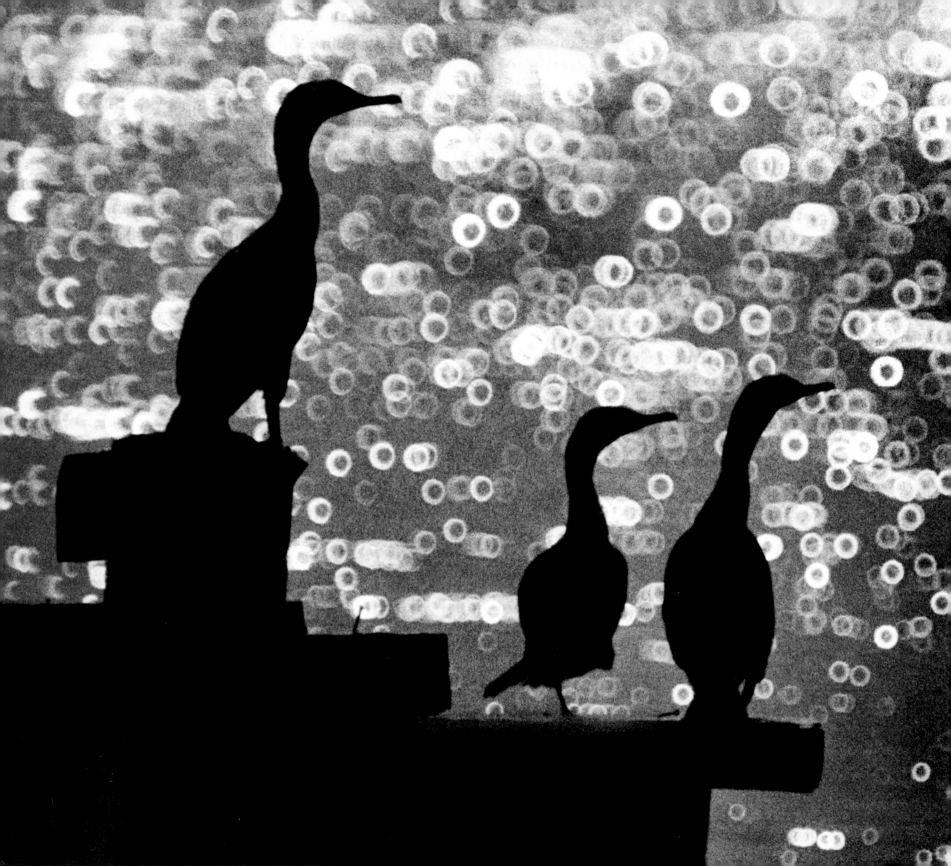

INTRODUCTION

Over the years, I've become increasingly involved with the so-called conservation movement. I've talked so much about it on radio and television that my office has become a regular meeting place for conservationists. We read and study and observe and then discuss and try to understand. We are all still learning. There's no prescribed course. Those accustomed to the formerly universally accepted infallibility of logic, find themselves "all at sea"—completely bewildered. It becomes increasingly obvious that man should never have "taken dominion over"—but should have volunteered responsible stewardship instead.

For Bill Damroth, whose beautiful photographs these are, the natural world first came into focus through the lens of a camera.

For me, it was a long trip that lasted from my childhood back before the First World War until I was almost fifty, and ranged as far as Mozambique and India. It began in the town of Hasbrouck Heights, where I was brought up after my family moved from New York in 1905, when I was two. At that time, more than half a century ago, although it was only ten miles in a straight line from Manhattan, Hasbrouck Heights was farm country. From the slight elevation of the town, we could see the buildings of the Manhattan skyline sticking up over the hills of Jersey City, Weehawken, and Hoboken along the west bank of the Hudson, but unless you worked in New York and commuted, it was quite a thing to take the train or the streetcar to the city. It required more than three

hours to get there and back, and by that time the day was shot, so it was something we never thought much about doing. There we were, within sight of New York twelve miles away, yet living in a little country town out in the sticks.

And I got a regular country boy's upbringing, for which I am very grateful. That priceless childhood provided the foundation for all my future campaigns with the real world, and for the ideas I've developed as I've matured. From my earliest childhood until I was fifteen I was in daily contact with the routine things of rural life—things that comparatively few kids know anything about today. Not only dogs and cats, but also chickens, because every family had its own chicken coop. And I knew about chores: there were ashes to haul from the furnace, rugs to beat, laundry to help my mother hang out, snow to shovel, firewood to chop, lawns to mow, and gardens to weed.

I also learned a lot about life and death. I didn't need a course in sex education to know that ducks and other fowl lay eggs and hatch them, dogs give birth to puppies and cats to kittens, cows to calves and mares to foals. The breeding of cows and horses and dogs and cats and chickens and pigeons was routine fare for rural boys and girls. I was also used to wringing the necks of chickens and cleaning them, getting them ready for my mother to cook. If we were having a turkey at Christmas or Thanksgiving or some other occasion, I first chopped the turkey's head off on the chopping block and then had to pluck the bird clean.

I knew about horses, too. From the time I was very small, I worked as a helper on horse-drawn wagons delivering bread and milk, ice, newspapers, and doing general hauling. So I knew how to muck out a horse's stall, how to groom and harness a horse, how to handle them and feed them. When we weren't working, I would straddle the bare back of one of those workhorses and ride him around as though he were Man o' War.

Actually, being poor worked out to my later advantage, though I surely didn't think so at the time. I had to work to help feed our family—there were five children—and the reason I was usually working in someone else's garden for wages is that the Godfreys never had enough time to get a good garden going; we were always being evicted for nonpayment of rent. And because we didn't have any money, even when I

wasn't working I couldn't do the same things for fun that many of the other kids did.

Nevertheless, it was not from necessity that I came to spend so much time in the woods and the swamps and in the ditches and the creeks. I loved the outdoors. That was my entertainment, and I was by choice pretty much of a loner. I was poor and wore secondhand patched clothes, but I had access to swamps that were unchanneled, untouched, unpolluted, and to deep woods and to clean water.

There were wild animals, too, in those days, even that close to the big city. The wolves and coyotes were long gone, of course, and the rare reports of wildcats brought the whole town out armed to the teeth. But we had plenty of raccoons, squirrels, and rabbits, and hawks and owls, eagles and falcons and muskrats, weasels, mink, and foxes. The hours I spent in the woods watching the animals, or in the swamp with the birds and the muskrats and mink and, rarely, a deer, gave me an insight into the natural world. I have always felt very much at home in the wild, developed a sharp eye—I could see extraordinarily well at night—still do!—and have almost an Indian's sense of smell. It was about as near as a poor boy could come to being a child of the wilderness, that close to civilization.

By selling art pictures and ointment, I won a Daisy air rifle and a commission from some bird club to bag all the English sparrows I could get. They were a plague in those days because they had multiplied fantastically after they had been imported into this country, and they were especially troublesome in urban and suburban areas where they fed very well on the oats in the horse manure that virtually paved the streets. I felt very important because I had the air rifle and an identification card that said I was to use it in a good cause, though my satisfaction was tarnished a bit by the bawling-out I got from some neighbors for sneaking up beneath their shutters and shooting the sparrows after they had gone to roost.

Then as now, there was a streak in young boys—call it nasty or mischievous or what you will—that hunting and killing other creatures seems to satisfy. (Needless to say, the same impulse persists in some supposedly mature men, as I was to learn later on.) I, too, used to love to shoot a neighbor's cat in the rump just to watch it jump. It didn't hurt the

cat much, but I thought it was great fun. I even tied cans to a dog's tail and watched the poor devil go nuts trying to shake them off, and I have painted a cat's behind with turpentine to watch her try to rub it off.

I don't know whether these impulses are some atavism that comes down from the time when man was an instinctive hunter for survival, or simply a "civilized" perversion of man's relationship to the rest of creation. Wherever the impulse comes from, we all had it, and my boyhood adventures with my Daisy prepared me for more elaborate hunting expeditions later in life when I had money to buy the rifles and shotguns to really do the job, never dreaming I was doing any harm.

As I grew up and left chronic poverty far behind, I moved up in the hunting world, too. I was often invited to join hunting parties in the Maryland marshes. Ducks, geese, and rail were the game, and there were plenty of them around. I'm sure I missed more than I hit, and it wasn't until years later that I learned how to shoot ducks. Still, I didn't mind: it was enough for me to be in the outdoors.

The first "big game" I ever shot was a white-tailed deer, on a private preserve in Michigan where I used to go hunting with some friends. But I didn't really learn anything about true hunting until I went into the woods with dear old Tom Gathright on his place near Covington, Virginia. I called him Uncle Tom—everyone did—and though he was in his late seventies when I met him, he was still more spry and agile than I was at half his age, and the best hunter and woodsman I have ever known. It was Tom who taught me to stalk game, which for my money is what hunting is really all about. He taught me woodcraft and to stalk wild turkey, deer, bear, and even such small and skittish animals as squirrels. I learned also what I now think is the most rewarding wilderness skill: the ability to walk through the woods as a wild animal does, passing feeding game without their being aware of my presence until they get my scent after I've gone on upwind.

The number-one rule at Tom's place when we were out hunting was always to make the first shot instantly fatal. If anyone missed, wounding a deer in the gut or the leg or even in the heart, wasting the meat and causing the animal to suffer, that hunter was never invited back. Uncle Tom was also the man who taught me to hunt like a natural

predator, to pass up the beautiful buck in his prime, with the gorgeous antlers that would look so fine on the den wall, and take the lesser specimen. These days the woods are teeming with itchy-fingered gunmen who shoot compulsively at anything that moves, without identifying the target. There are many, incredibly, who take "sound shots," firing in the general direction of any sound in the woods, hoping to score a lucky hit somewhere, on something. We lose quite a few hunters that way, but nowhere near enough!

But always and increasingly I dreamed of Africa, where the big game was. I wanted to shoot lions and leopards and buffalo. I still had the common notion that animals like these were vicious, ferocious, dangerous killers. And I wanted to be the big, brave hunter. I had been hunting in the Rockies for puma and bear as well as antelope and elk. Even so, by the time I finally went to Africa on my first safari in 1957, I was fifty-four years old and still as green a horn as there ever was when it came to really big game.

Ironically, it was that long-awaited safari to Africa, together with another one seven years later and one to India in between, that turned me finally away from hunting, from the killing of wild creatures. It all came to a head quite suddenly at the end of the second African trip, in Mozambique. I was hunting leopards, and I was still ignorant enough not to know that I was making a mistake right there. Even though there wasn't as much talk then as there is now about "endangered species," I should have realized that the animal I was hunting was all too rare when the guide told me they hadn't seen any in that area in many years. But I pressed on, fixed on the vision of a beautiful leopard-skin rug I'd always wanted to have as a trophy. One day, as we were driving along, my guide started gesturing in great excitement toward the bush, and I saw what looked like leopard spots. The animal was too far away to notice that I jumped from the jeep and lay still while he fixed his attention on the moving vehicle. Carefully stalking to a sensible range, I squeezed off a clean shot to the heart, thanks to old Tom, so the beautiful creature died instantly. But when I saw its feet I cursed, because I realized that I had killed a cheetah, which was taboo! I had him mounted just as he was standing so I'll never forget.

Still, I kept hunting. We had seen a herd of sable antelope, a magnificent species, and once again I should have realized that they were not plentiful because we kept seeing

the same herd day after day, and no others during the whole three-week safari. We studied the herd through field glasses, and of course we picked out the best-looking pair of horns, the best bull in the bunch. Once again we used the jeep as a decoy, and I stalked to within about three hundred yards of the quarry. I was upwind, so I didn't dare get any closer. I steadied the rifle and fired, but I must have flinched 'cause I hit him in the shoulder instead of the neck, where I could have killed him instantly, and he ran off. But I knew I had hit him because he veered off to the right, favoring the wounded leg. So we noted his direction and waited for him to lie down. By then the only thing in my mind was to put him out of his misery. When I came up on him, I saw that the bullet had broken his shoulder, but even so he got up and tried to fight. I dispatched him with a neck shot. I looked down at him, and I said to Walter Johnson, my guide, "Walter, you just saw me kill the last antelope I'll ever shoot."

That was the end of that; I've never gone trophy hunting since. I shoot no more birds, even; never will unless I'm very hungry. The only exception is an occasional wild turkey, which I'll take if I'm very sure there are enough of them around. And I still shoot white-tailed deer in Virginia, but in that case there's a very good reason: there are simply too many of them. We've killed all the predators that would normally keep the population down by taking the weak, the sick, and the feckless, so more deer are born and survive, and at the same time we've turned most of their natural range to our own civilized purposes, forcing a growing deer population into a constantly shrinking space. Because deer feed on the browse that grows around clearings, they are forced to invade human settlements, so there's inevitable conflict. I won't touch raccoons or foxes or any predators—hawks, owls, eagles. And when I shoot deer, I don't call it sport. I shoot skeet and trapshoot for sport. I shoot deer only when the browse line is high and the deer gaunt.

As a matter of fact, I wonder if the term "sportsman" has any meaning at all any more. I have seen estimates that "sportsmen" chased down 700 polar bears with airplanes and helicopters in 1970 alone. In mid-1971 a helicopter pilot admitted to flying "sportsmen" who killed 770 bald eagles over a six-month period. What kind of horrible scum can these people be?

The only way hunting could be called "sport" would be to hunt armed only with a

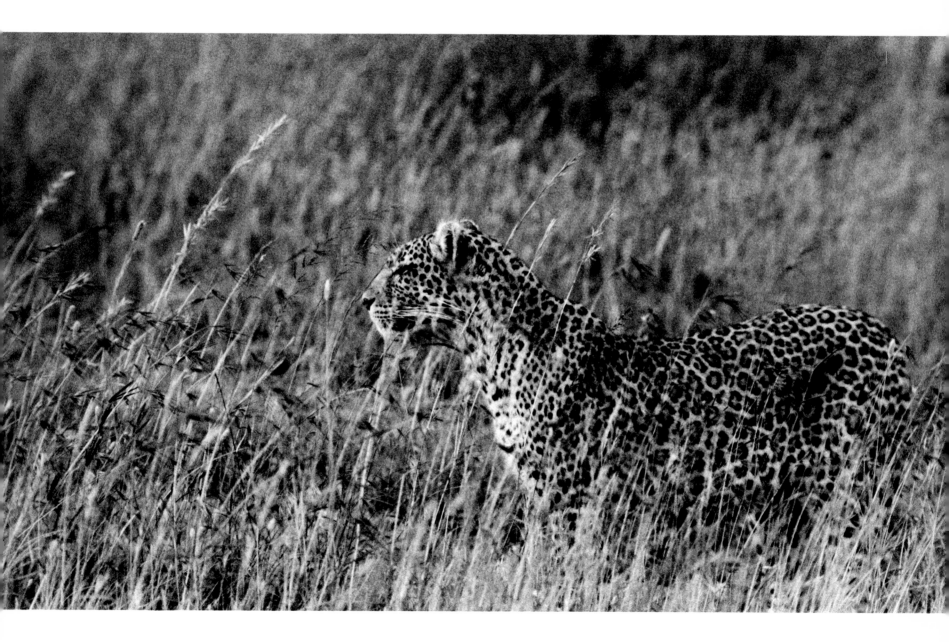

spear or a bow and arrow, on equal terms with the animal. Instead a "sportsman" takes a high-powered rifle with a telescopic sight from two- to three-hundred yards, and if he can hold the rifle steady he can kill anything. If he's lucky and doesn't just wound it, the animal never knows the lout was in the neighborhood!

In the only sense that I can use the word, "sportsmanship" involves an ethic of hunting, which means respect for the rest of creation. At the very least, this means that we should no longer hunt species that are in any danger of extinction. Even the Bible, after all, while it seems to give man "dominion" over the rest of creation, does not license the extinction of other forms of life. Nor, in the more secular view, are we the custodians, much less the emperors, of the evolutionary process. In my opinion, if there is such a thing as a sin against creation, the killing of a member of any species, except for vital food, is it.

The very fact that many species have become extinct in this century, due solely to man's lust for profit and plunder, is an ominous sign. These expiring animals must be viewed the same way miners look at canaries deep underground—as indicators of atmospheric quality. If a canary in a mine suddenly dies, the miners know it's time to get out. Many scientists and students of human environment, in an analogous way, consider the virtual disappearance of certain predator birds as a sign that our own environment is dangerously poisoned. But I'd go further and claim that man's destruction of any of his fellow species is a sign of spiritual poison as deadly as any chemical.

I think there's even more to it than that. I think that respect for the rest of creation also involves respect for the ecological integrity of every living thing, the recognition that everything is equally involved in creation in a complex series of interlocking cycles, and that to interfere with any of these is to tamper with the integrity of life itself. In practical terms, this limits man's killing to animals that he has domesticated for his own use, other animals like the deer for which man has made natural existence impossible, and the rest of the wild creatures only when they are necessary for food for man's survival.

As the late Aldo Leopold wrote: ". . . we are all fellow creatures in the odyssey of evolution."

ARTHUR GODFREY

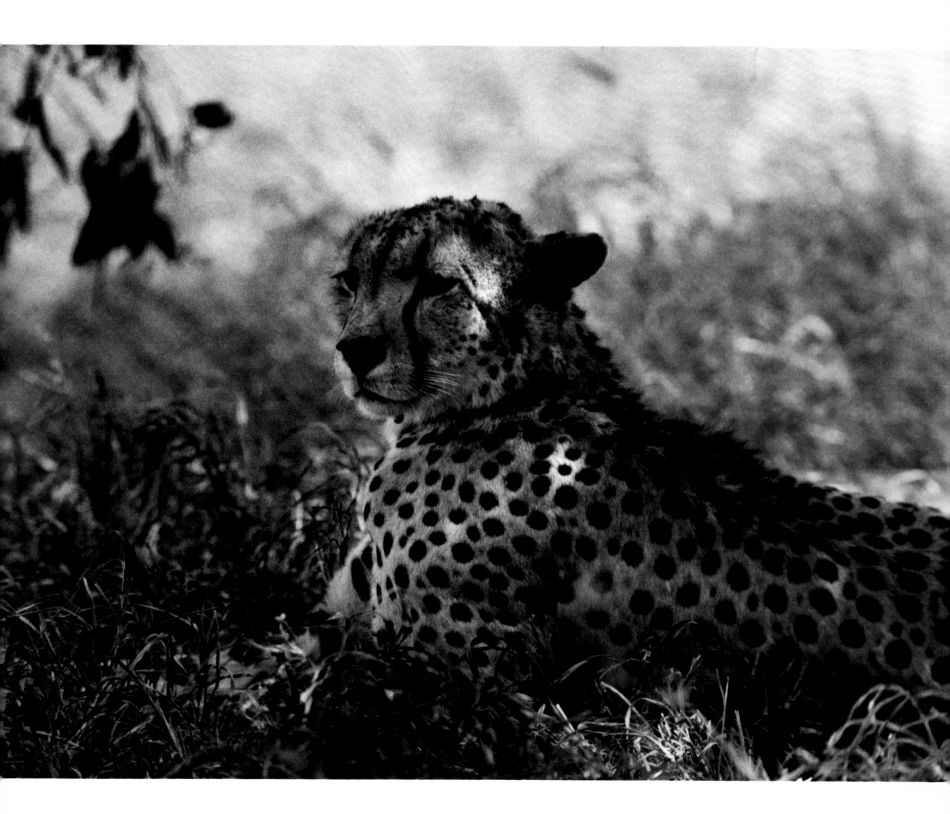

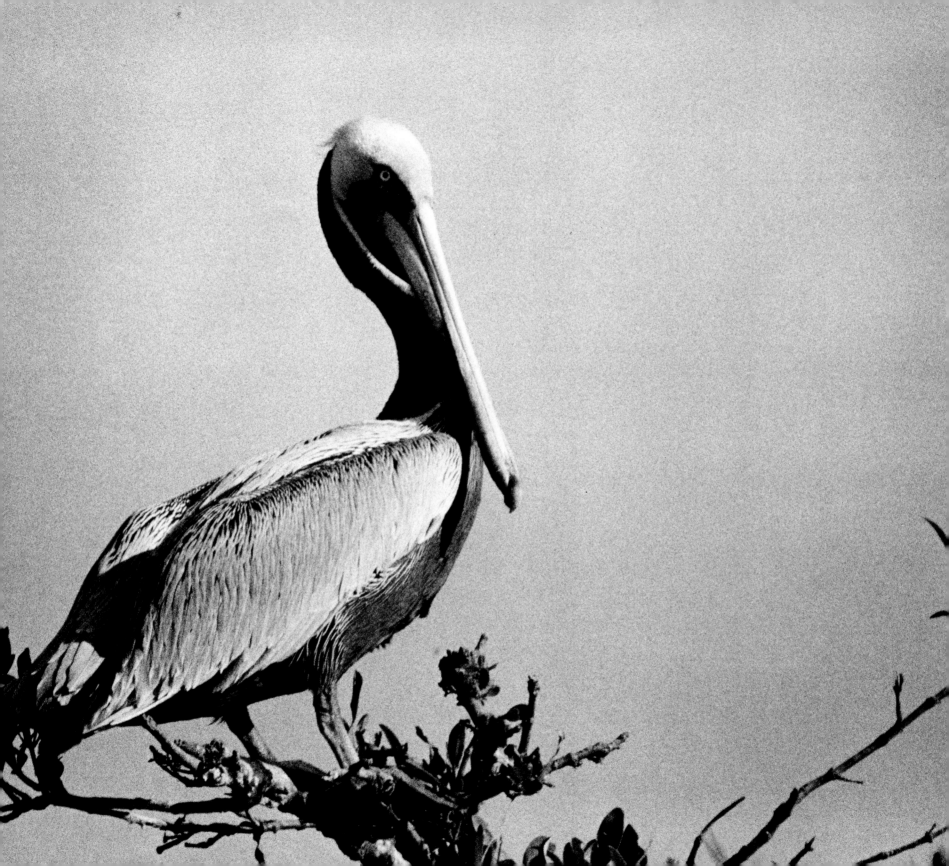

PASSPORT TO NATURE

I must confess that I am neither a full-time conservationist nor a full-time photographer. My only purpose in adding still another book to the already heavily laden shelf of nature books is to call attention to the domain discovered by the growing ranks of wildlife amateurs, who like myself frequently flee man's crowded cities to seek peace in nature's world.

Those who are bored and depressed by an impersonalized computer society, who are angered by the ear-shattering roar of diesel trucks, the stench of unclean streets, and the dull gray view through polluted skies, I invite to join me in discovering the pleasures of nature.

Today I am deeply involved with nature, but it was not always so. My African safaris, my trips to New Zealand, Tahiti, Fiji, and other places in search of nature were not professional assignments; they were a part of a much longer personal voyage for me.

I was very much a child of the city, born to a landscape of concrete, asphalt, and skyscraper mountains, with city sparrows and pigeons my only wildlife. My games were city games, and the closest I came to a real wilderness adventure was the occasional expedition to the park to go goldfishing with a bent pin and a wad of sticky dough, or a day spent in a rowboat with my father, fishing for flounders in the bay, a few miles from the city.

Like many children then and now, I experimented with photography. At fourteen I had finally saved enough errand tips to buy an Argus "candid" camera. My father helped

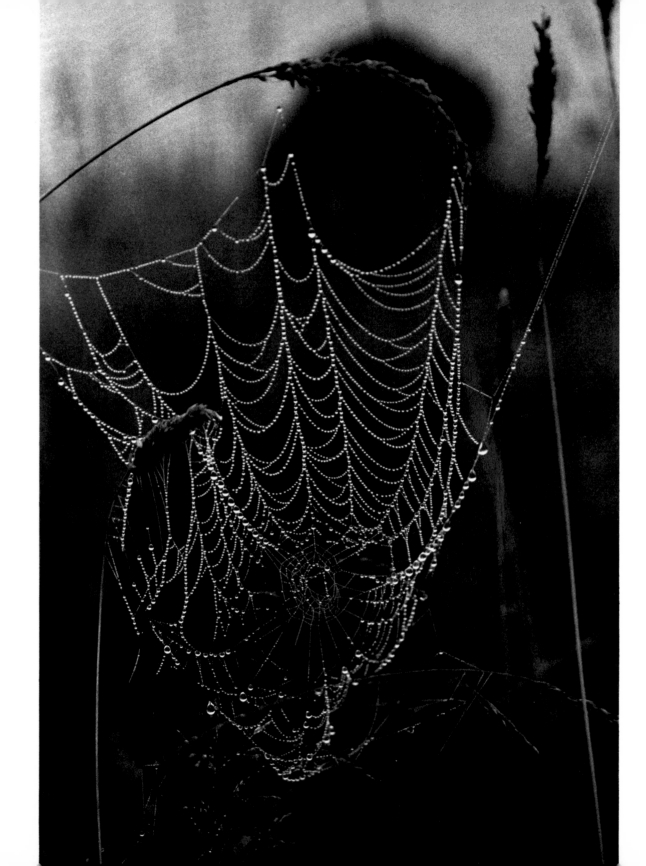

me to build a little darkroom in a janitor's workroom. "Sauna bath" would be a more accurate description for that unventilated black broom closet where I often had to keep the film emulsion from melting by putting ice cubes in the developing tray.

I grew up in the same way as most city children, and like many of them, I emigrated to the suburbs with my wife and there raised three sons, only to suffer the dull, daily commute back into the crowded city. Photography was still my one hobby. A closet darkroom setup was allocated to me as family photographic historian, but with business pressures my interest in photography took a back seat and each child received less photographic attention. Soon even my darkroom disappeared with the growing needs of an expanding family.

By the material standards I knew, I was "making it," but through the years I gradually began to wonder if business success was worth making that dull daily round trip. The increasing insults of the impersonal, overcrowded city and the inadequacies of part-time living in suburbia were catching up to me; the faster I climbed the business ladder, the more quickly frustrations overtook me; the more goals I reached, the more often I found overwhelming dissatisfaction and emptiness waiting for me at the finish.

Eventually, after too many years of this kind of self-punishment, I ended up in one of those confrontations with the face in the bathroom mirror. I saw an aging young executive, running out of time. I saw a successful man without joy, an urban sophisticate without wisdom. I realized that, with all my material possessions, the greatest thing of value I possessed was *time*. It was surprisingly easy for me to take that a step further to realize that if my early business success was good for anything at all, it was to buy me freedom to use this remaining time in more meaningful ways.

Without knowing it, I had already found my means of escape from this deadening routine. For several years I had been taking my family on increasingly frequent and far-flung escape trips out of the urban-suburban maelstrom for brief vacations, long weekends, and for summer stays on a farm. During these sojourns out of the city, my interest in nature photography grew. It had been sparked by the new improvements brought about in negative color film and low-cost processing, and by the purchase of my first single-lens reflex, an Olympus Pen F.

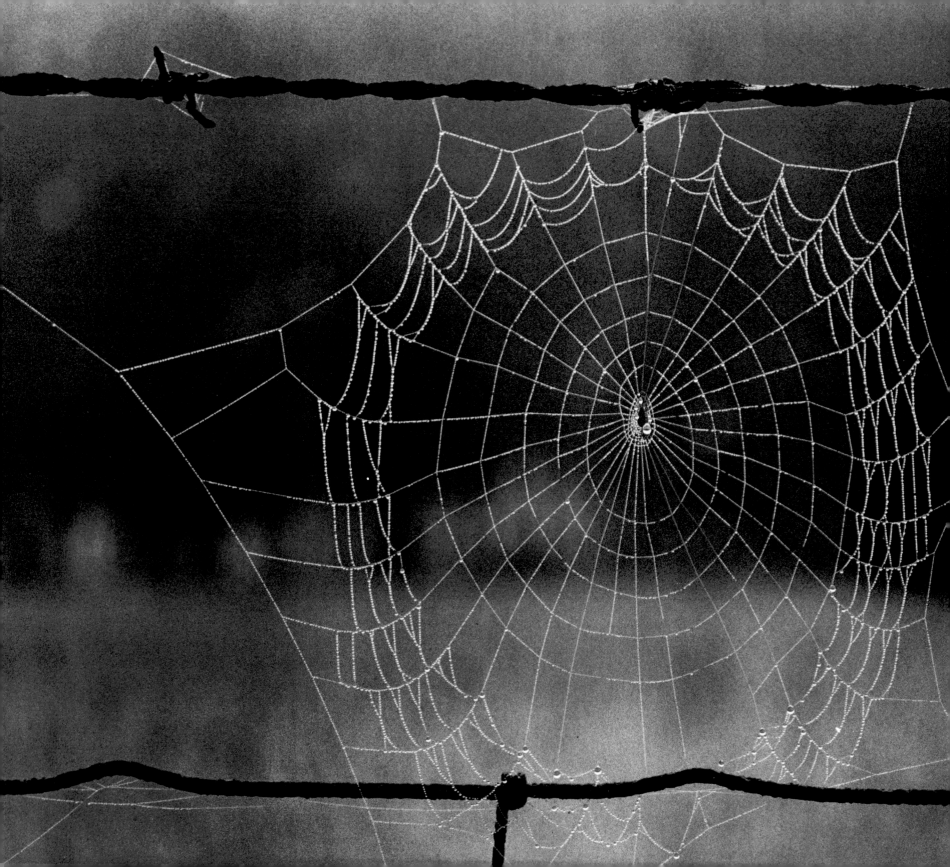

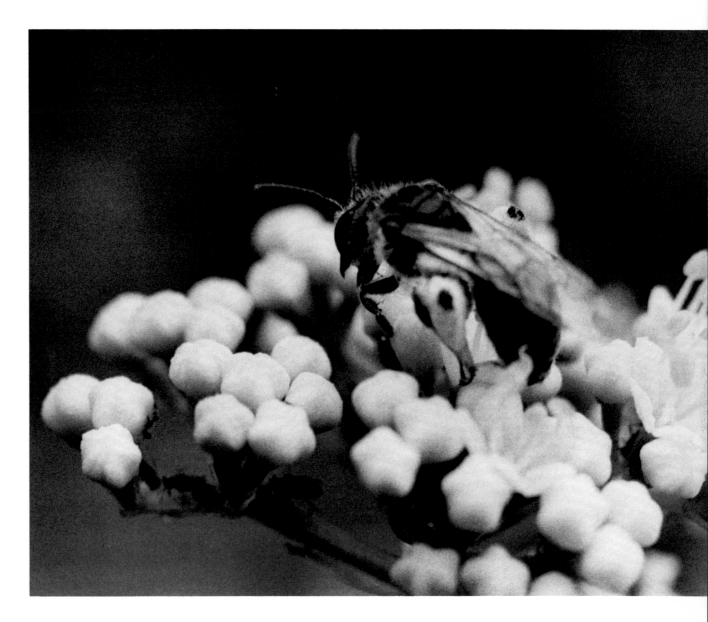

I took my new toy to Martha's Vineyard; I was anxious to try it. The very first morning I loaded the camera with a roll of Kodacolor film and left the farmhouse long before my wife and children were awake. A heavy ground fog lay over the fields as I began my expedition. I got on my hands and knees and pushed my camera into the mist again and again as I peered through the viewing screen, focusing down on dewdrops, on bees poised upon the Queen Anne's lace, and on silvery spider webs. Soon the sun began to penetrate the drifting fog, and each dew-drenched spider web became a necklace of sparkling jewels. Unaccustomed to such everyday wonders, I was like a child—excited, overjoyed. I had made a discovery. Spider webs—how perfect were their patterns, how delicate their threads, how beautifully they glistened in the dew.

That camera brought me more joy than I had known for a long time. It brought me close to the world of little things: insects, flowers, seed pods, fossils, toadstools, and seashells. It brought me closer to nature.

For the first time I began to thrill to the excitement of "seeing." My camera began to unfold for me a new, exciting world. My eyes, dulled by years of reading newsprint, legal documents, and accounting reports, of scanning gray office buildings and black asphalt streets, suddenly became aware of what nature had to offer. The closer I peered with my probing lens, the more I found myself marveling at nature's designs and at its variety of ever-changing colors. But it took another lens at the other end of the optical range to bring me close to more elusive wildlife and to bring my own life even closer to the world of living creatures.

It was not without some hesitation and several false starts that I went out and invested in an extreme telephoto lens, a 1600mm mirror optic called a Questar. As its name implies, the lens is primarily intended for celestial photography and observation, but it has been adapted for use in nature photography, where its extreme power of magnification makes it invaluable for capturing the images of elusive animals and birds without disturbing them.

Once again Martha's Vineyard was the site of my first experiments. It was early summer, and the herring gulls with their newborn young were scampering over the dunes. Peering through the new lens, I spied on baby gulls as they tottered about, studying their

habits from a vantage the most patient and practiced ornithologist of the past would have been unable to achieve. My new lens was a perfect tool for my purpose, but I was an imperfect beginner. Although the effective focal length of the Questar is folded into a relatively short ten-inch body by the use of mirrors, the compact instrument that results is heavy and, especially at first, maddeningly cumbersome to use. But I mounted lens and camera on a heavy tripod, headed for the sand dunes, and began snapping away, determined to master my new instrument, knowing each time even before I heard the closing of the focal plane shutter that I had let my impatience get the better of me and wasted another frame of film.

I tried various combinations of shutter speeds, using both Tri-X and Kodachrome film. It seemed impossible to photograph those moving targets as they wandered among the dunes. The telephoto's limited depth of field meant I was constantly adjusting the focus, and the narrow picture angle meant a tripod adjustment every time the subject moved a few inches. To add to these frustrations, I was going blind trying to watch my subject through a viewing screen darkened by a tiny f/16 opening.

At the end of two hours I had only three rolls of exposed film, and I felt sure that most of those were worthless. I had mixed emotions. I was excited by what I saw, but I was frustrated by the technical problems I encountered.

Even though I was prepared for failure, I was terribly disappointed when my negatives came back from the lab. Most of the pictures were hopelessly out of focus; my inexperience was compounded by the use of too slow a shutter speed. Besides the problems of fuzzy pictures, most of the shots were poorly framed, as though I had lost all sense of composition. In some frames, subject had eluded me entirely, leaving me with an out-of-focus picture full of sand and grass. But in all those 108 frames, there was one black-and-white negative that seemed sharp, so I decided to gamble the price of an 11″ x 14″ print. At least I would have the satisfaction of seeing what my new lens could do, even if it confirmed my own lack of skill.

The salon print came back from the lab in four days. It was a close-up profile portrait of a herring gull, so handsome to me that I must have stared grinning at it for twenty minutes. It was by far the best picture I had taken during my many years as a camera

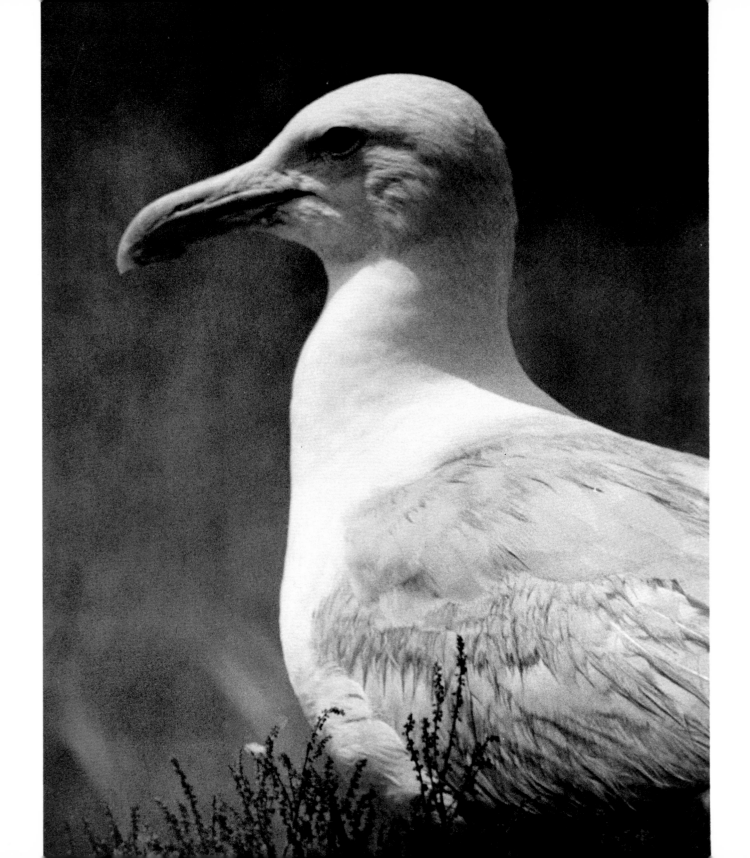

novice. Immediately I forgot the hundred-odd wasted frames on those three rolls of film; to me, this one picture was worth all of the film, effort, and frustration. In those twenty minutes I realized the camera could be my passport out of the city and the world of business.

Since then the search for wildlife has taken me to many places: Kenya, Tanzania, New Zealand, Fiji, Tahiti, and Bonaire. Of all the places I have visited, the south Florida mangrove islands and the shallow bays in which they occur will always remain one of the most peaceful natural retreats I've found on earth. Between these islands formed of closely packed mangrove roots dropping like long fingers to the fertile bottom, even the breeze of the open bay is hushed, and I find real peace. The silence is only occasionally broken by a strange bird cry coming from the impenetrable tangle, or a splash of a snook or tarpon feeding nearby.

One day when I was poling my boat slowly among the mangroves, looking for birds to photograph, I spotted a handsome Louisiana heron. With the Questar, which I had by now learned to hand-hold, I was able to follow the heron's search for his next meal. Tri-X film developed to ASA 1800 made possible a shutter speed of 1/1000, to freeze my moving subject and shaky hand.

The waters were still, and the mirror surface reflected the little heron as he edged out over the water on a slender branch. Suddenly he froze—something beneath the surface had caught his keen eye. He clutched the branch tightly in his thorny grip, his neck arched taut like a steel spring. I held my breath and strained to balance the heavy telephoto on my knees as I photographed frame after frame.

The heron's head shot swiftly down, his bill pierced the water cleanly, and a small fish was transfixed and eaten. Of the more than twenty frames I shot of this sequence, it is the one of the tense moment before the strike that epitomizes the event for me.

Even for the most successful professional photographer the art is full of surprises. No matter how carefully the equipment has been selected, no matter how complete the photographer's concentration on the action of his subject and his awareness at the moment of exposure, it is often something quite unexpected that lifts a photograph beyond the ordinary. This is particularly true, I have found, in wildlife photography, where one

concentrates so much on the subject's action that unnoticed background designs, back lighting, or strange optical effects produce many a happy accident.

Late one afternoon I sat alone with my camera and watched an egret move gracefully along the beach on Captiva Island, in Florida. I stayed motionless on a huge pile of pectin shells, the abandoned homes of thousands of tiny sea creatures, watching the plumed bird scan the waters as he stepped slowly up the beach toward me. The wind was onshore, and the dark gulf waters were breaking along the beach. The low sunlight haloed the bird from behind as I activated my motor-driven Nikon, shooting three frames a second at high speed to freeze the motion of bird and water. I had taken the full 36-exposure roll in five short sequences before the bird passed me—enough frames to be reasonably sure I had at least one good shot.

Several days later, when I saw the result, I felt that the photographic re-creation had surpassed the event itself, producing an image in harmony with my own feelings at the time. My 500mm telephoto lens had pulled in the distant breaking waves and made them seem to tower over the bird, when in fact the waves were many feet beyond the egret and no more than eighteen inches high.

One of the reasons I now choose to spend my time with nature photography is that there is only a short span of time between the creative intention and the final result—the time between my decision to risk a shot of something I have composed in my viewfinder and seeing the finished print, all a matter of days or even hours—an almost instant gratification. This is quite different from my experience in the administration of a business. The idea for a new sales program, a new product, or even a new company often burns brightly when the idea is first conceived. Then comes the slow sifting of the idea through battalions of lawyers, staff executives, underwriters, accountants, and government departments, and the slow, tedious modification by all the supernumeraries of the organization system, until the excitement of the original creative impulse is dissipated and even the eventual success is joyless and unsatisfying.

Today when I have direct control of my creative efforts, from the selection of subject, the location and composition, to the processing and the print paper, I can better understand why one of my sons talks of being a carpenter; he wants to make something with

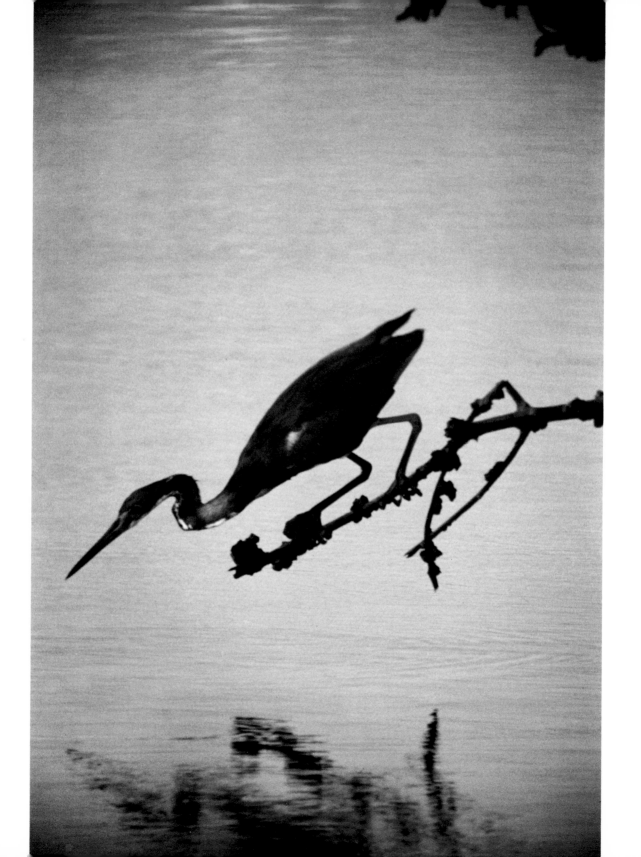

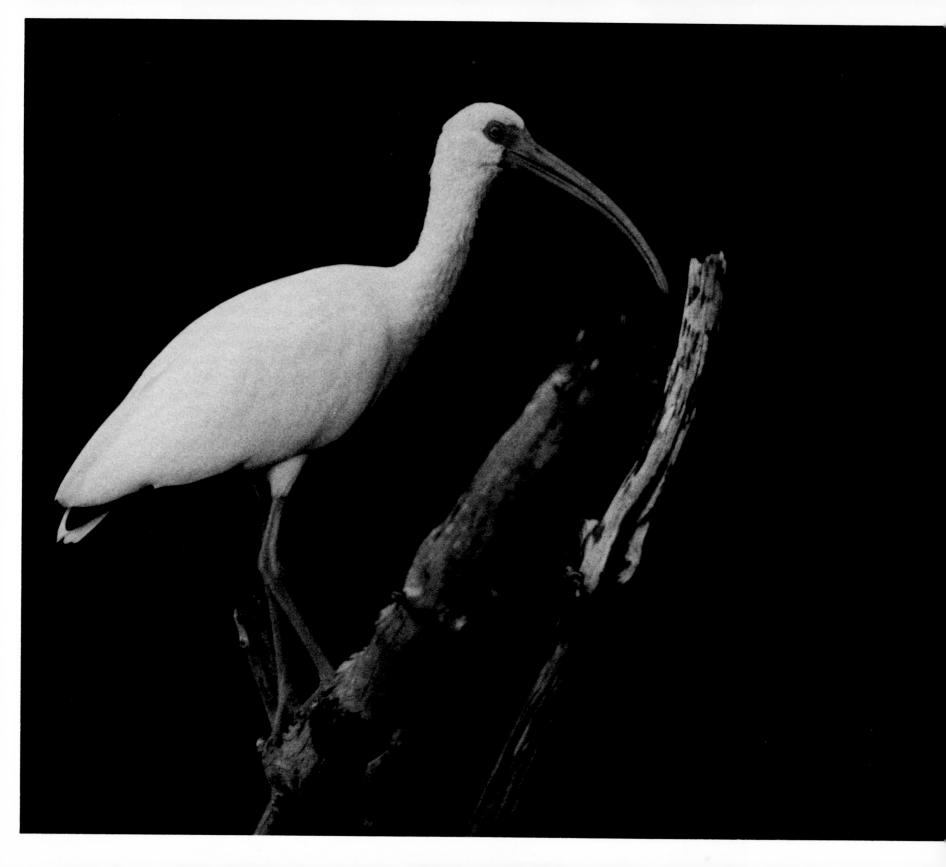

his own two hands, look at the result, and take pride in his accomplishment. I understand, too, why so many young people are returning to small farms and raising their own food. They want to re-establish contact with their own creativity. It feels good; it's as simple as that.

One of the greatest satisfactions of wildlife photography lies in the opportunity to photograph a rare creature. It is as though the photographic record, however inadequate, somehow saved that species from extinction, in the same way that portraits of people confer some kind of immortality. My own encounter with one of the last of his kind came by chance in the Everglades.

From high on a dead branch of a tree, a majestic creature stared down at me with piercing eyes, his head darting momentarily first to one side and then to the other, but with one eye always on me. Evidently finding me harmless—as indeed I was, marooned far below his high perch—he at last set to preening himself and stretching his great wings as I photographed him, looking for all the world like a high-fashion model posing for *Vogue*. It was not until the pictures were developed and printed that I learned the identity of my lofty subject; he was a rare Everglade kite. About one hundred of his kin still soar their native Everglades skies, the scant survivors of a much larger population dragged down by the hand of man. They have been decimated over the past years by the destruction of their habitat and food supply as rampant development overtakes the South Florida wilderness. As a final indignity, poachers rob the Everglade kite's nests for the eggs and sell them for high prices to collectors, for whom a sterile egg is more precious than a magnificent bird flying free.

For me, the soaring flight of a graceful bird arouses a wonderful sense of freedom. Sitting on a jetty in Menemsha one day in late summer, idly watching the incoming tide, I saw a tern darting madly above the rushing water, taking advantage of the tidal feast of shiners. I went back to my car for my telephoto lens and a light-green filter and returned to the end of the jetty to expend several rolls of film on the tern as it darted and hovered over the water, searching for food.

I later learned that this little bird is a member of a traveling family. One of his smaller cousins, the arctic tern, travels more than 25,000 miles a year to make the round

trip between his winter and summer homes, setting out for the Antarctic each year with unerring navigation.

I met other members of the tern family on the Firth of Thames in New Zealand. There I photographed a colony of hundreds of nesting white-fronted terns; as I approached, their chatter became screams of violent objection and the colony took to wild flight. I was fearful that these dive-bombing fighters would attack my head, but as I lay on my stomach, in position to take my nesting shots, the noisy terns stopped their screams and one by one settled back to their twenty-four-day incubation vigil.

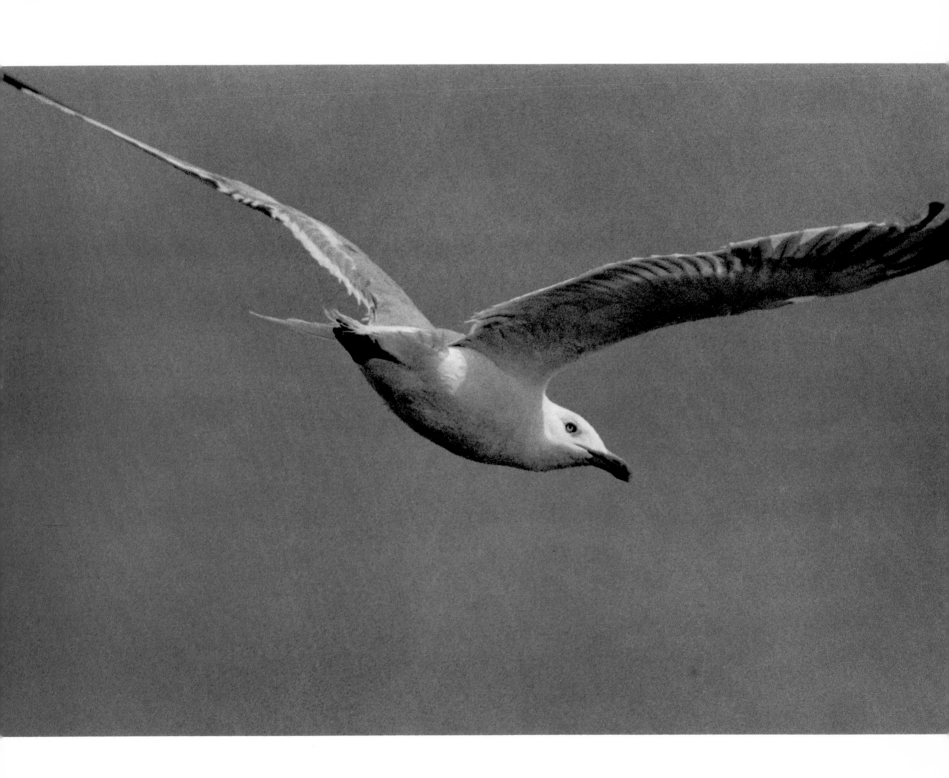

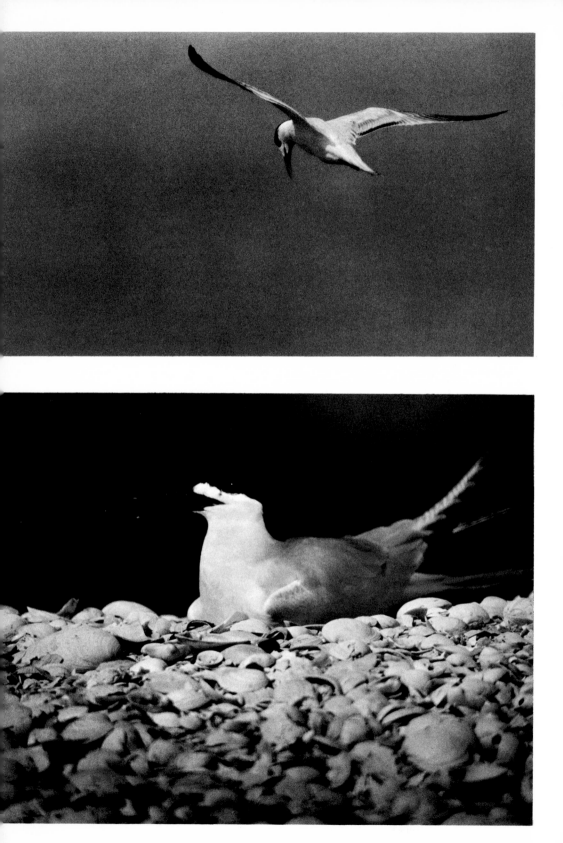

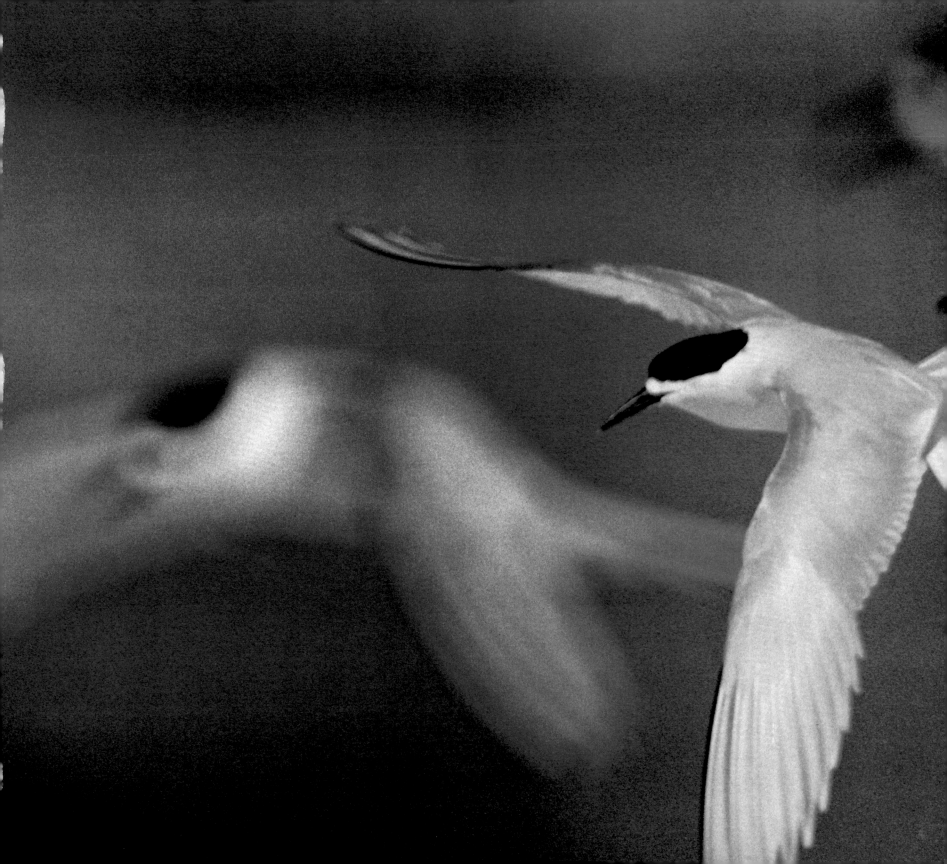

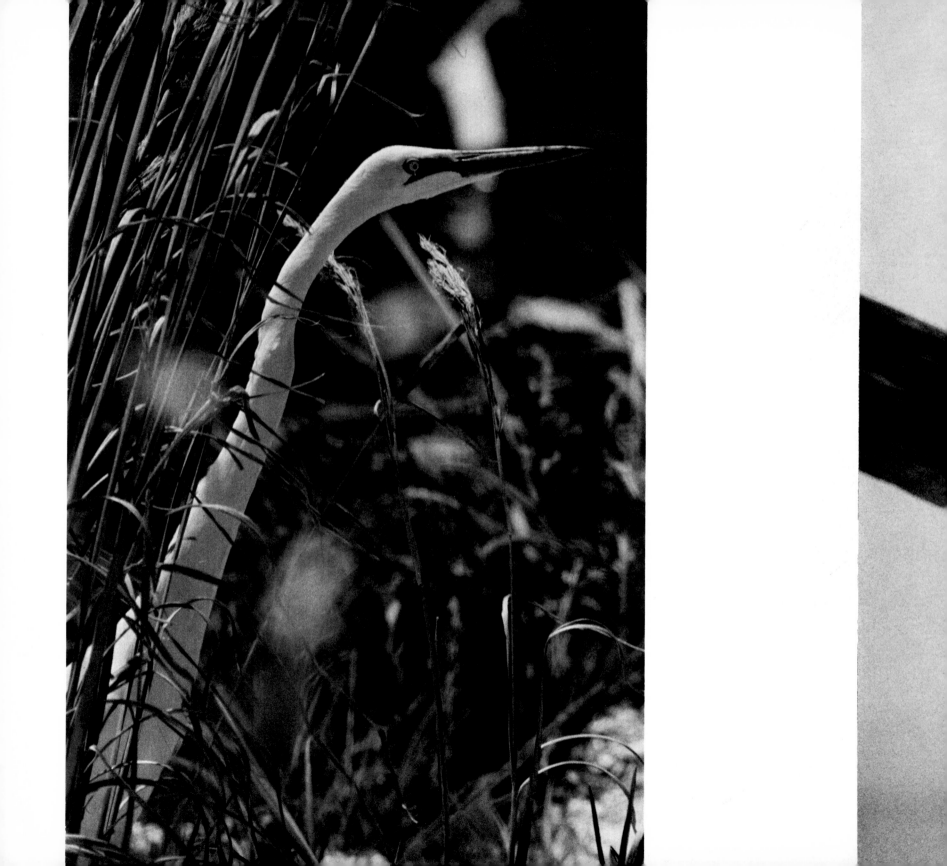

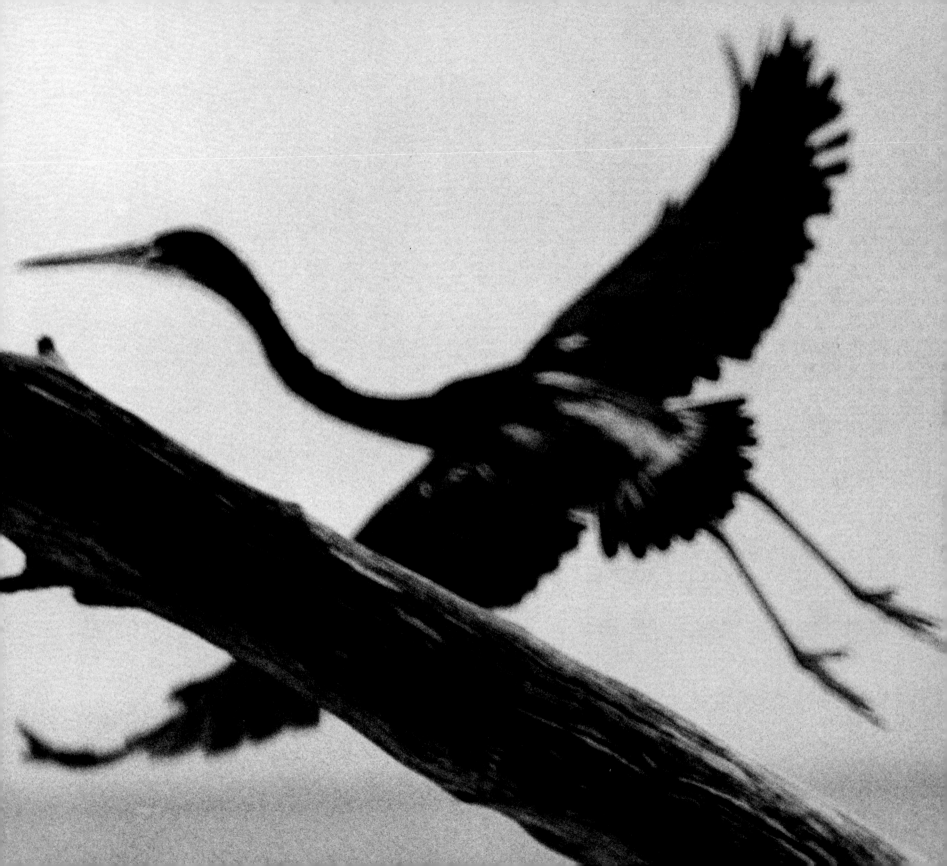

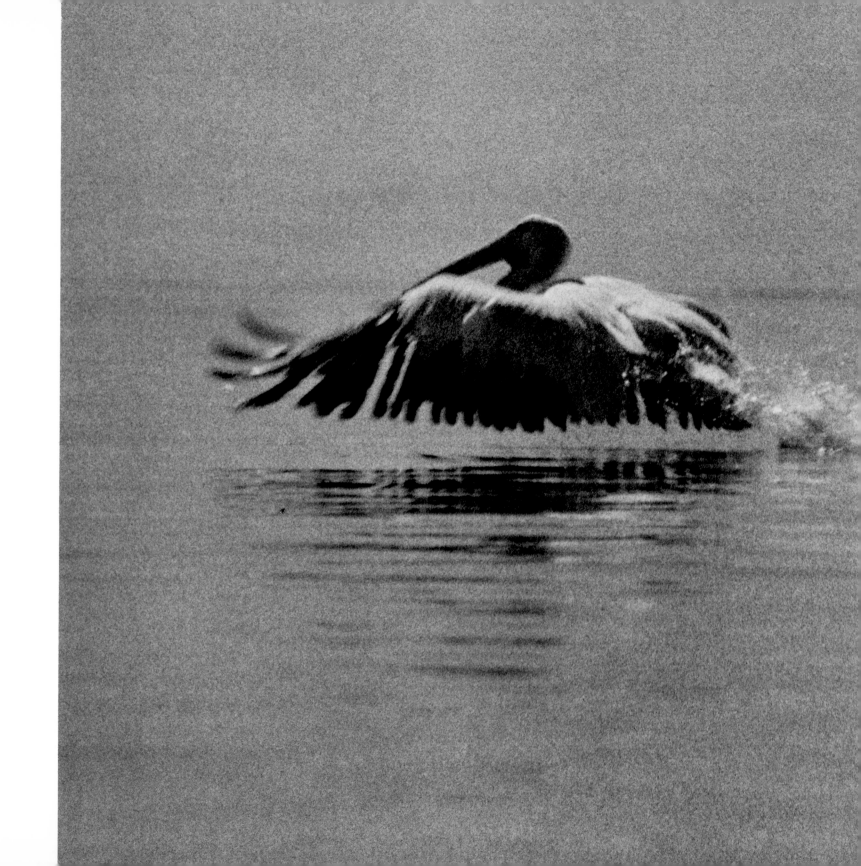

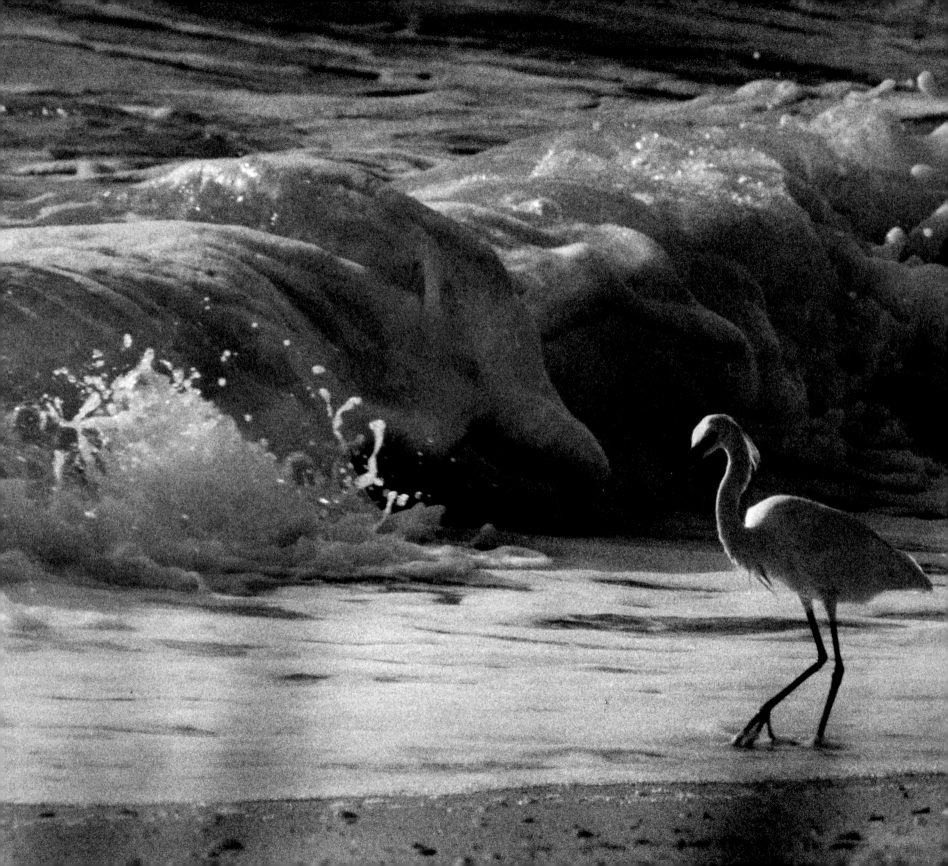

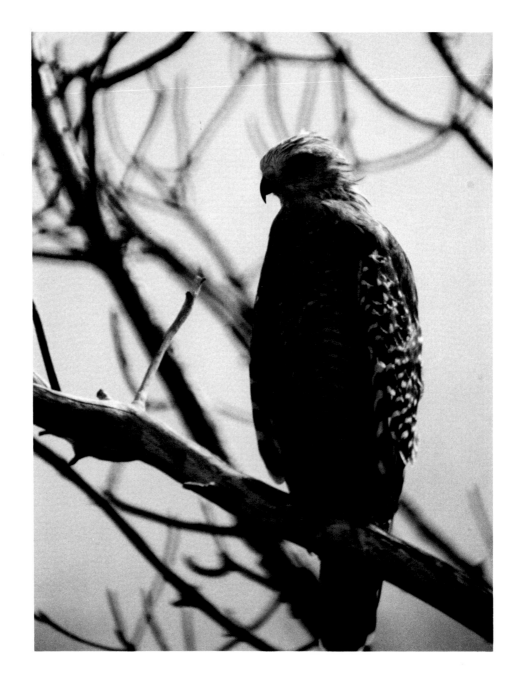

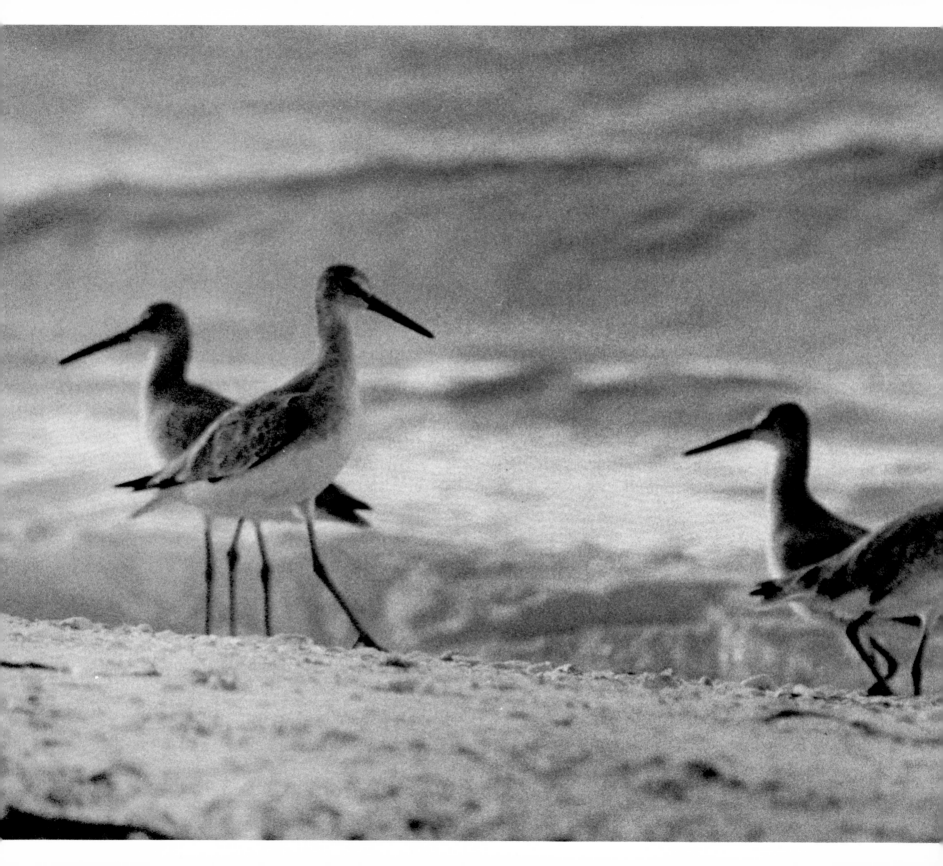

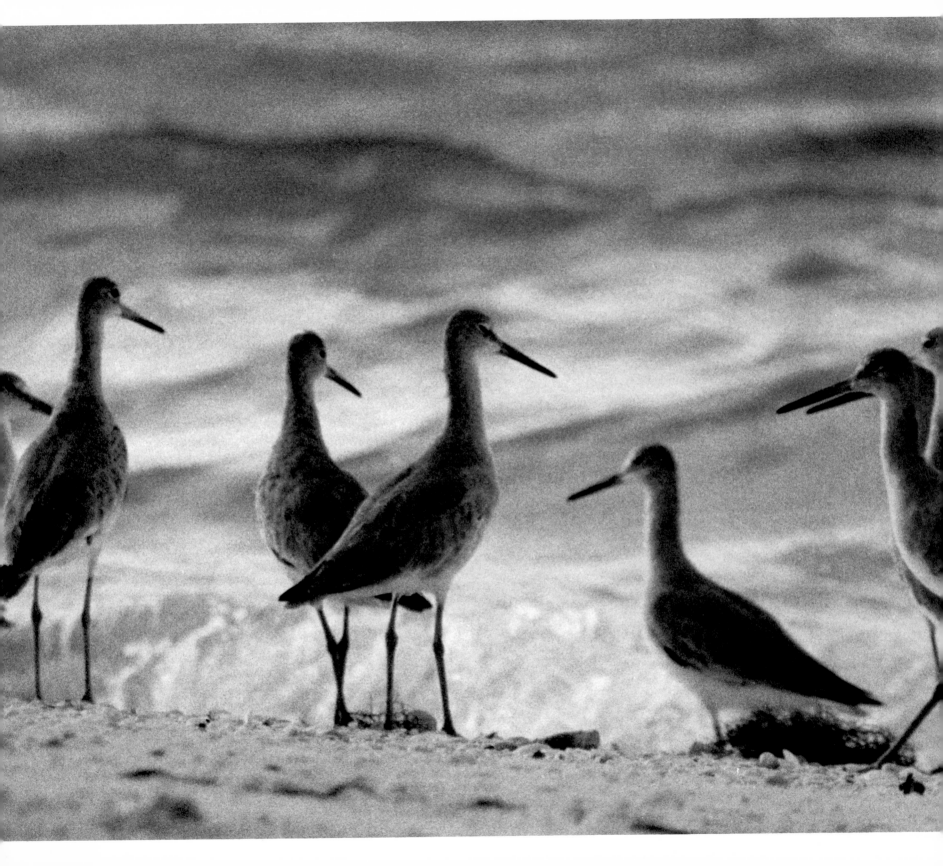

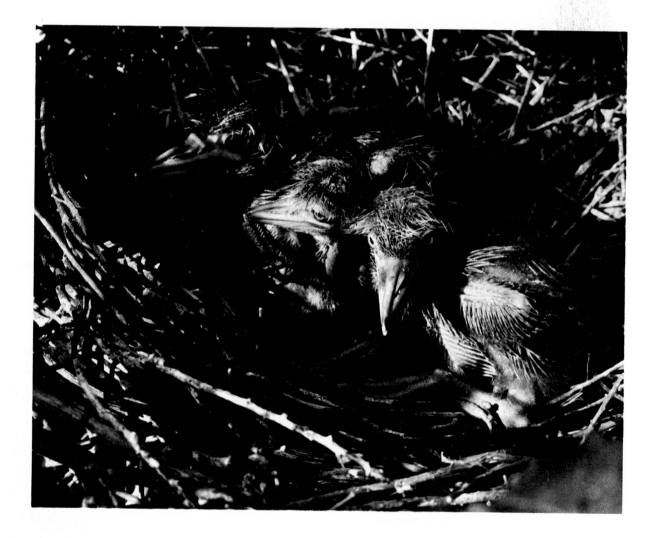

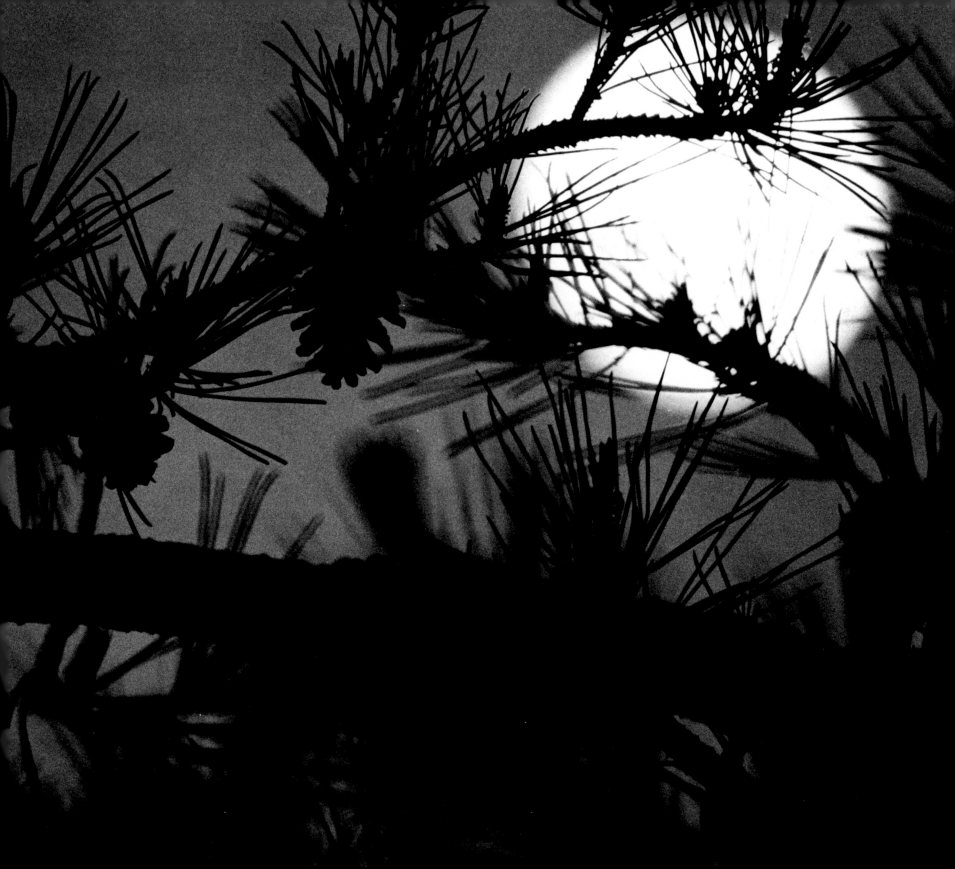

For many modern men, including most certainly myself, the very idea of wildlife necessarily involves Africa, where the delay of modern industrial development has left huge areas in their primeval wild state, their animal populations as untamed as they were a thousand years ago. I have been drawn to Africa ever since my childhood fantasies were fed by Frank Buck's documentary movie *Bring 'Em Back Alive*. Several years ago, as the phrase "undeveloped countries" ominously shifted to "developing countries," I felt I had to see the wildlife of Africa for myself before it all disappeared, for indeed it would. I made two photo safaris to Africa in one year.

On my first visit a huge male baboon gave me the worst fright of my African adventure. We had been driving for two hours to reach a bend in the river where hippos had been sighted. It was noon, and my guide and I were tired, dusty, and thirsty as we parked the truck in a shady grove. There was a family of baboons feeding nearby, so I took several shots of a huge male before going to the back of the truck to get our lunch. I was handing my guide our box lunch when a huge ball of fur crashed between us, grabbed the box in its powerful jaws, and ripped the box right out of our hands. The surprise attack left us in shock: six inches either way and the animal would have had a mouthful of fingers . . . ours.

Our fright soon exploded into laughter as we watched our attacker stop his headlong rush, sit on his haunches, and slowly examine his prize. With agile fingers he carefully removed a ham sandwich from its plastic bag and began to eat. My impulse was to ask him if he wanted mustard.

By contrast, an encounter with a female baboon and her baby produced a pleasant photographic surprise—a unique print from a seemingly ruined negative. A number of

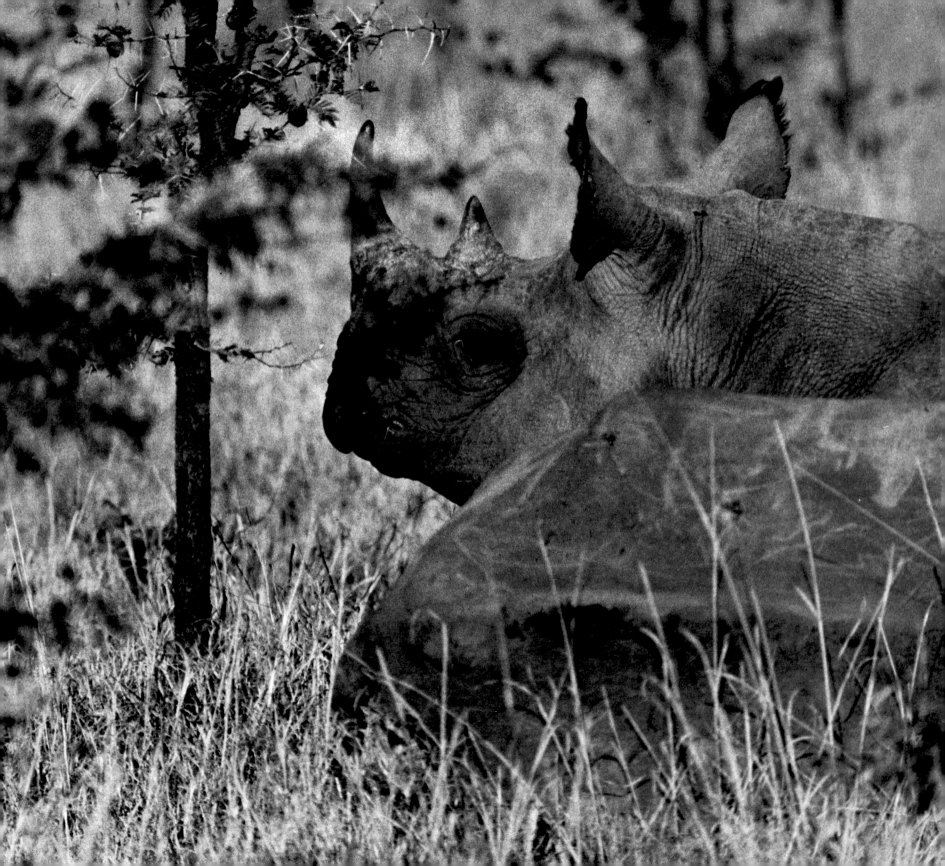

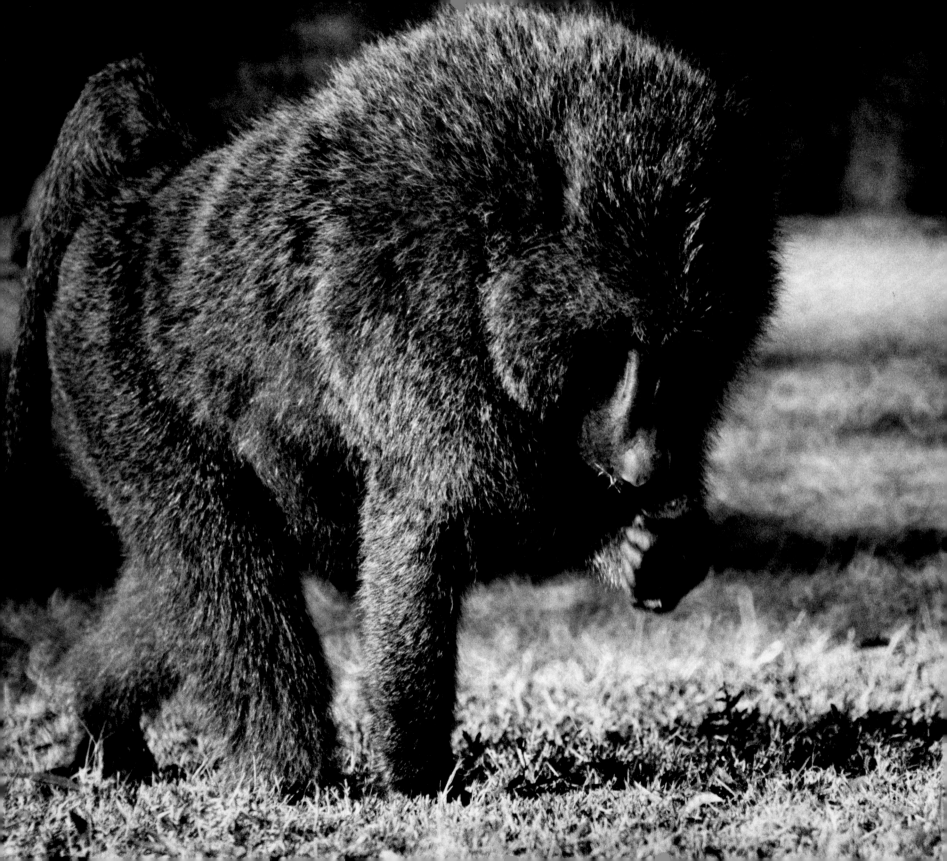

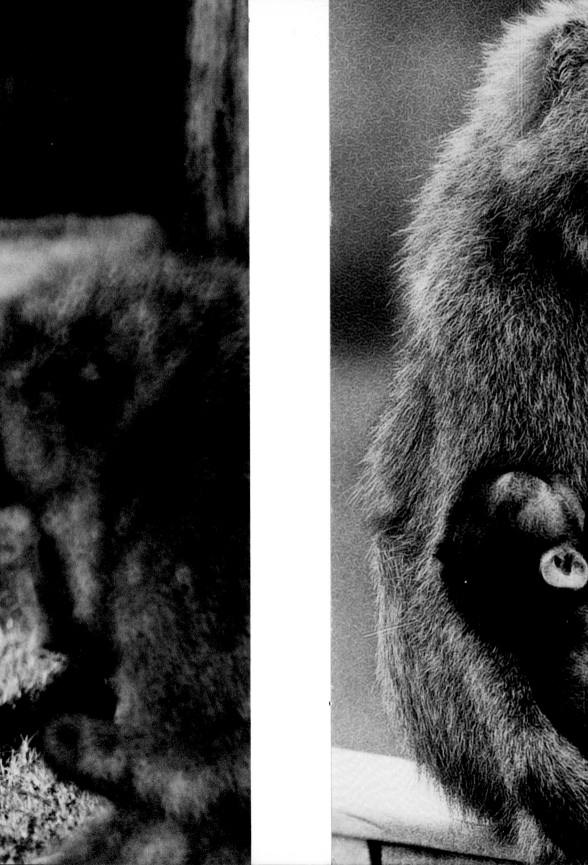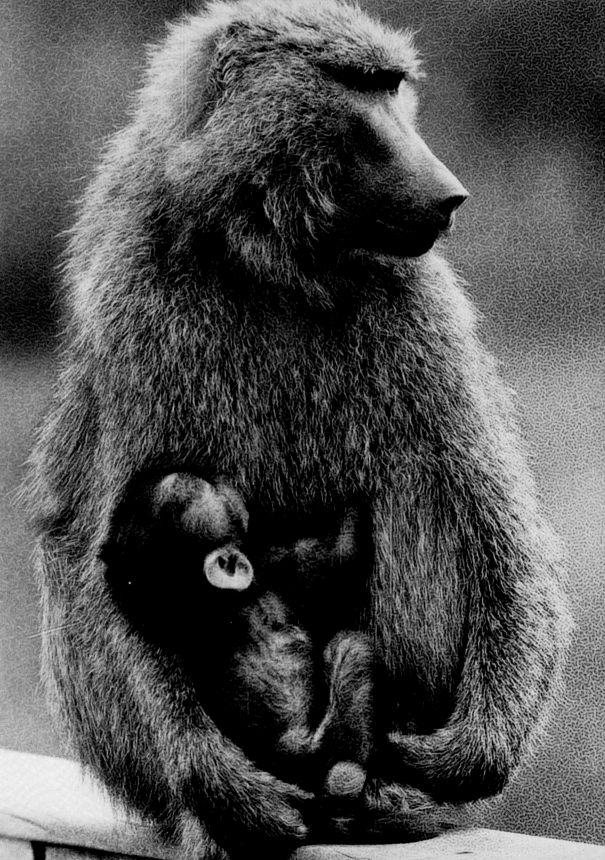

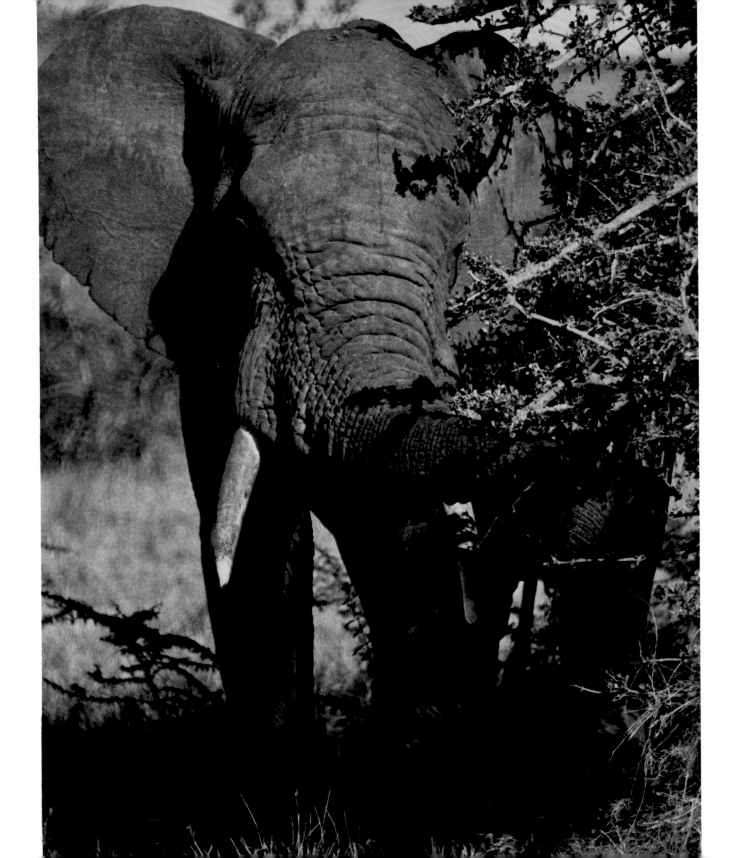

films had been subjected to the excessive African heat, and it was only after these were developed that I saw the result of that overheating: a reticulated pattern covering the entire length of film. I was shattered, but I was also curious about several of the better composed negatives, so I enlarged them anyway and was rewarded with "Mother and Child," a one-of-a-kind photograph.

Before I reached Africa, I had never dreamed I'd ever be very close to an uncaged lion, but one evening in Masai Mara in Kenya I sat with friends in front of the warming campfire and heard the distant thundering roar of these great hunters. We decided to get an early start to see if we could locate the lions and their kill. The next morning, soon after we rolled away from camp, my sharp-eyed guide spotted a young male and his mate quietly resting in the tall grass, still hungry after an unproductive night of hunting. For the next ten minutes, and from a safe distance, I photographed their every move and mood until at one point the young male kept moving toward me so that my telephoto lens could no longer be focused. I was too busy adjusting the lens to realize just how close he was.

On a quiet stretch of river in Masai Mara, my guide suggested that we might find hippopotamuses. I left the truck and quietly moved toward a high spot on the river edge while my guide, rifle in hand, stationed himself nearby, alert for any unexpected animal attack. When I finally had an unobstructed view of the river, I was unable to see any sign of life. I shrugged my disappointment to the guide, but he motioned for me to sit and wait. He was right. It wasn't long before six hippos which had submerged for safety came floating up out of hiding. I continued to photograph this amusing family group until daylight began to fail.

Early one afternoon on the great Serengeti Plain in Tanzania, I hurriedly left my tent, grabbed my 400mm Novoflex, and scampered to the truck. One of the returning guides had spotted a leopard. Because of the incessant illegal slaughter of these and other big cats for their skins, these beautiful animals are becoming more rare every day. We had covered the past thousand miles without spotting a single leopard. This was our first sighting.

The afternoon shadows were getting longer and the herds of zebras and wildebeests

49

were meandering along the horizon when we at last found the leopard lounging comfortably on the shaded limb of a huge old acacia tree, sheltered from the heat of day. Above, in his second-story food locker, where it would be safe from hyenas and jackals, he had draped his meal for the coming days, his kill a large Grant's gazelle. The leopard made a handsome subject as the lights and shadows of the setting sun moved slowly across his face and piercing eyes. He obligingly moved about, snarled, but mostly stared at his intruders.

The next day we were in luck again. A young leopard, normally a night hunter, was spotted on the scent of a small dik-dik, hidden from the leopard but not from our six-foot-higher vantage point. The tiny eighteen-inch-high antelope, aware of the danger, remained frozen to the ground while the big cat snaked his way through the tall oat grass, his keen scent often taking him within twenty-five feet of his frightened prey. I tracked him through my finder for more than an hour of fine photography before he gave up his quest and went on, hungry.

A giraffe running free on the African plains made me appreciate for the first time the grace and beauty of this shy and seemingly awkward creature. Whenever I tried to photograph him, he usually took off in a gallop. Watching him run was like watching a movie in slow motion as that long neck slowly rocked back and forth with each stride of his spindly legs. When I finally got the rare close-up portrait shot, it showed beautiful long lashes and black outlined eyes that would make Cleopatra envious.

It was in Tanzania, in the first cool minutes following the dawn, before the sun's burning rays could cut the cloud cover over Ngorongoro Crater to ignite the daily inferno, that I spotted a small band of zebras moving slowly along the edge of the lake. Tracking a vulnerable straggler through my camera lens, holding him in critical focus, I quite suddenly realized somewhere underneath my conscious mind the special relationship that existed between the zebra and me. For a brief moment we were hunter . . . and hunted. With my camera I had isolated, in some intuitive and unscientific way, my primeval memory of the hunter that lies deep in every man . . . but a hunter without the lust to kill. In the next split second I released the shutter and captured the soul of my subject, without taking his life.

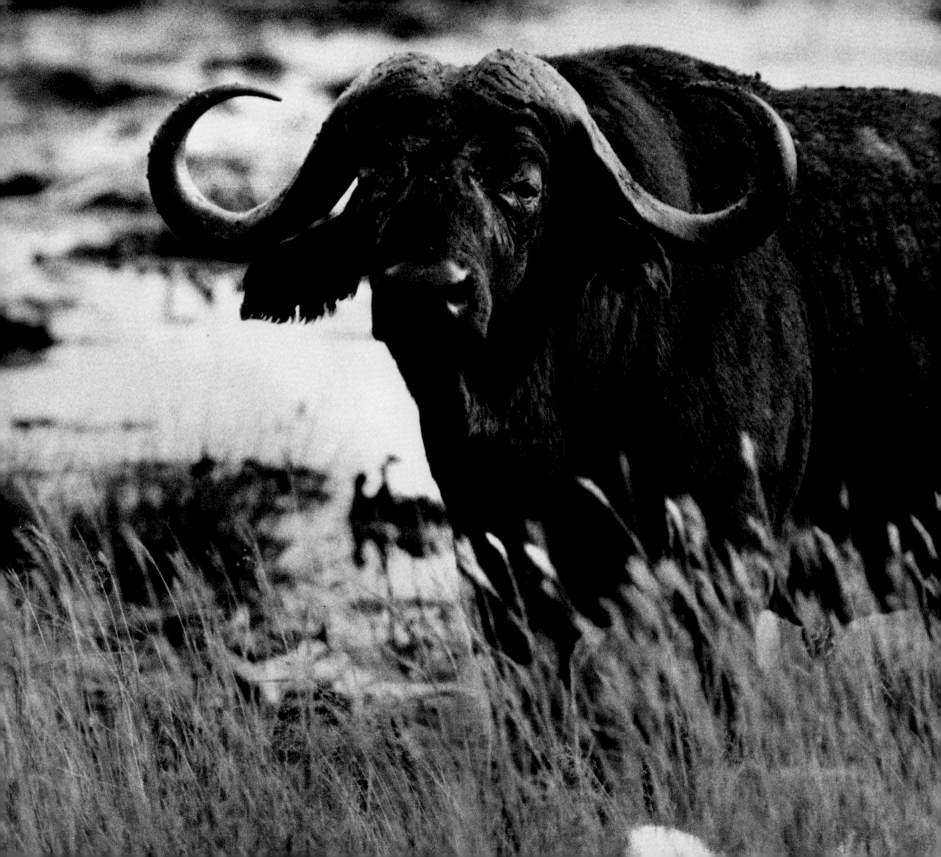

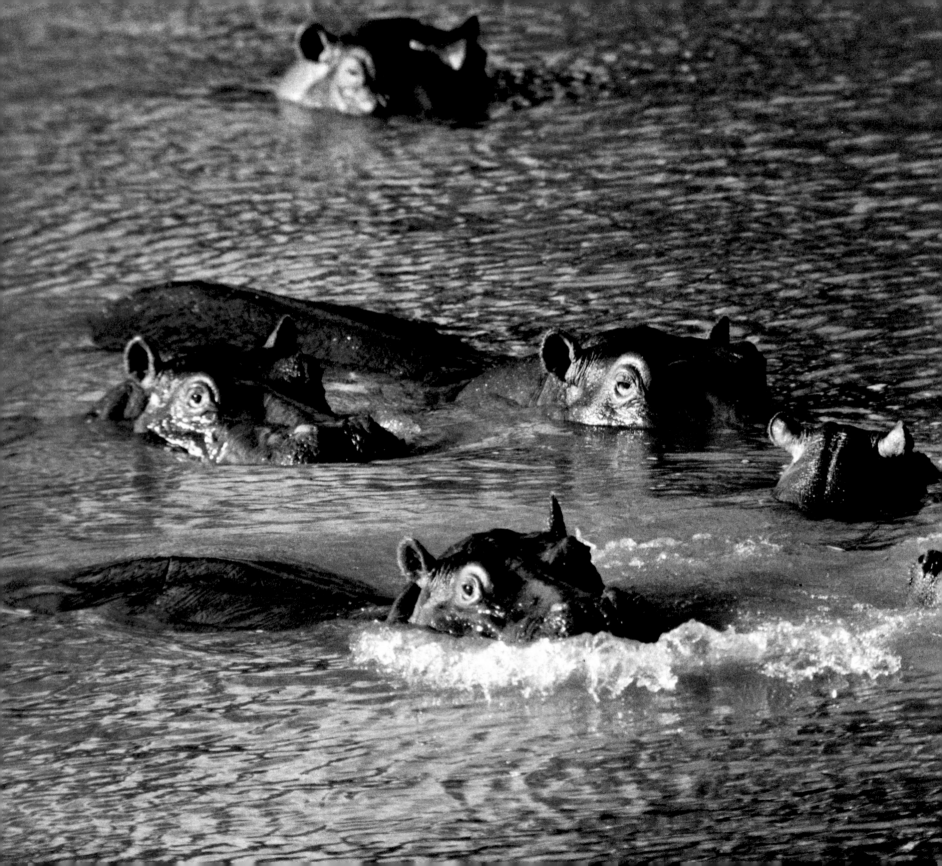

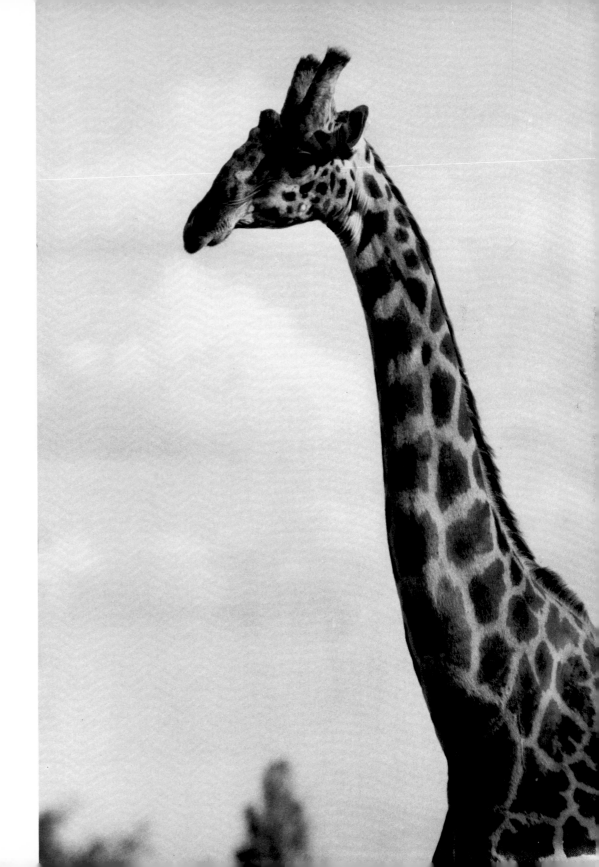

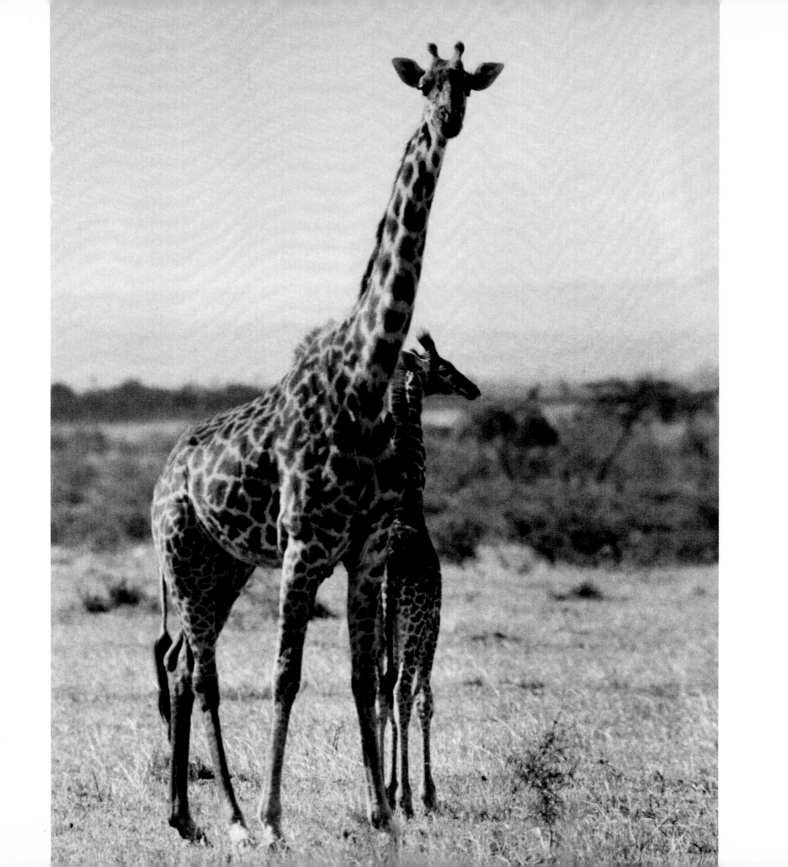

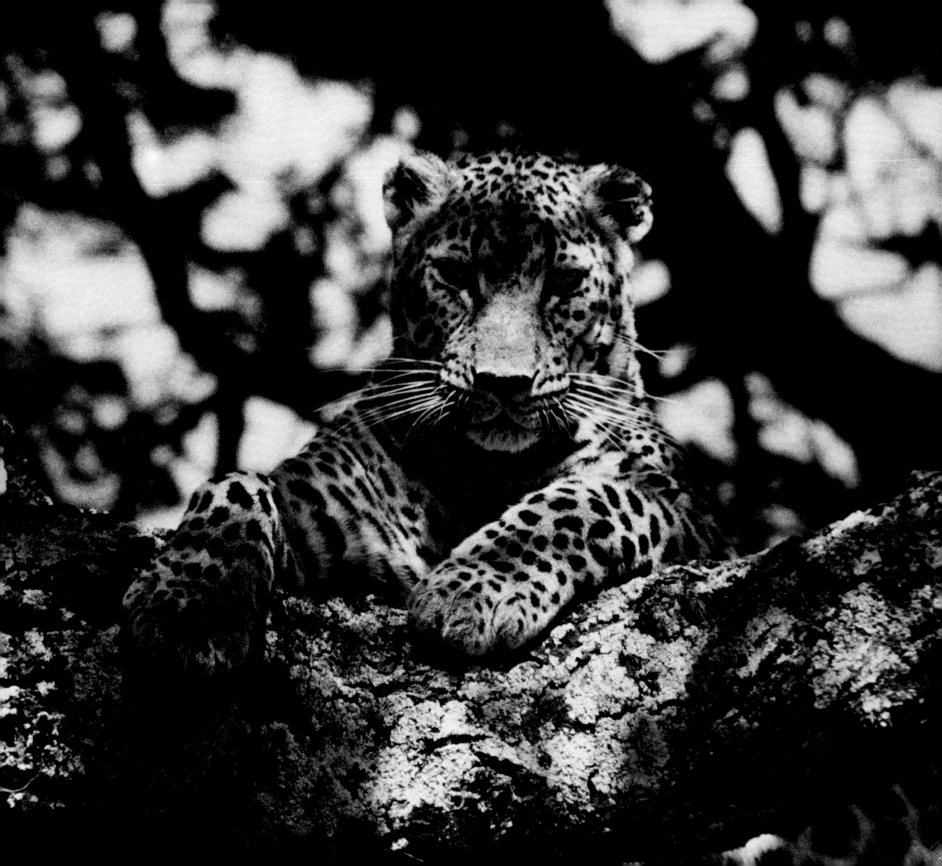

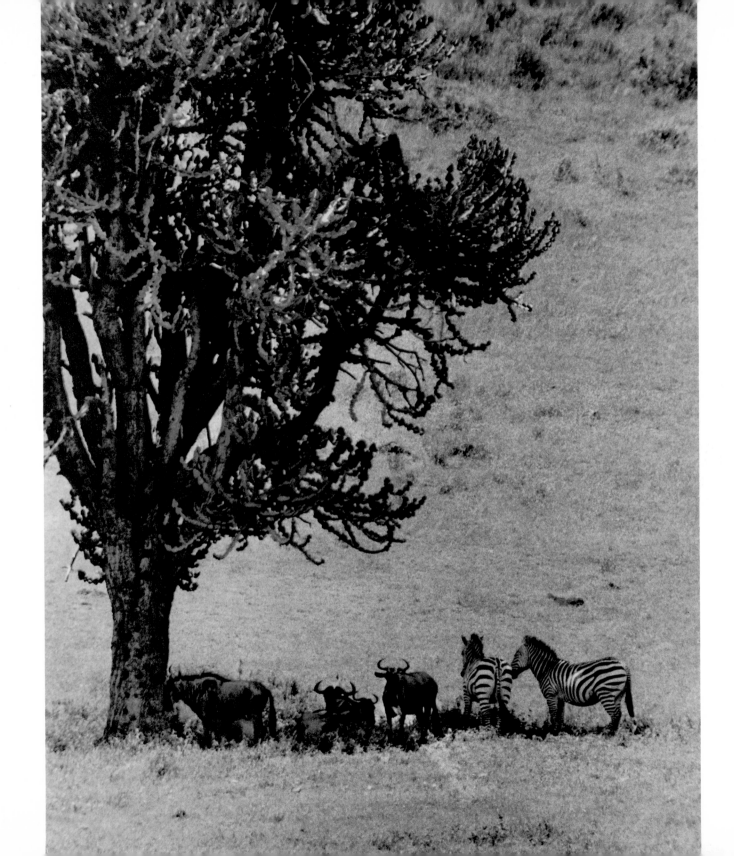

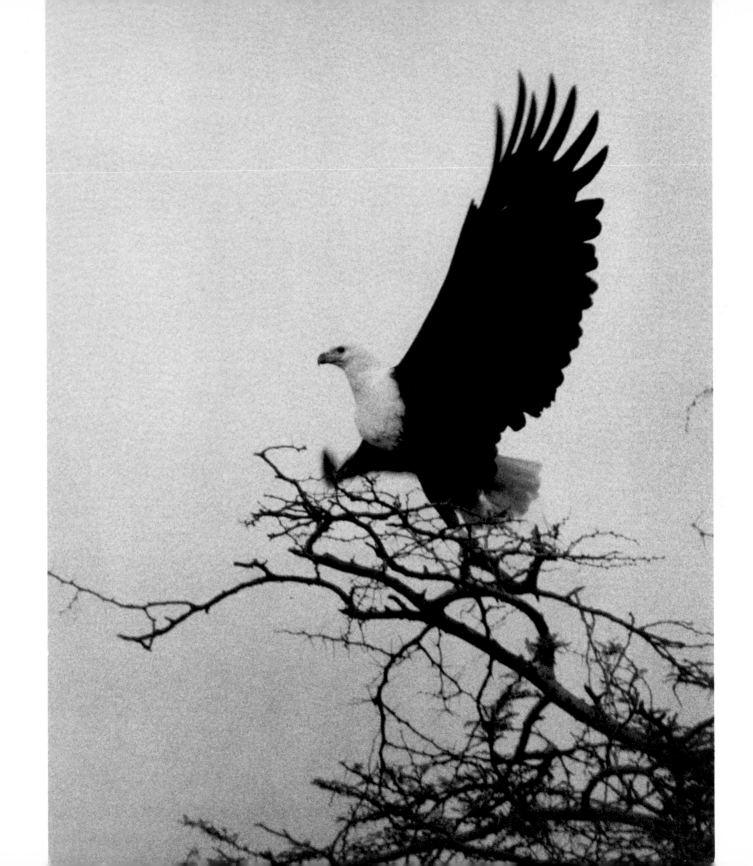

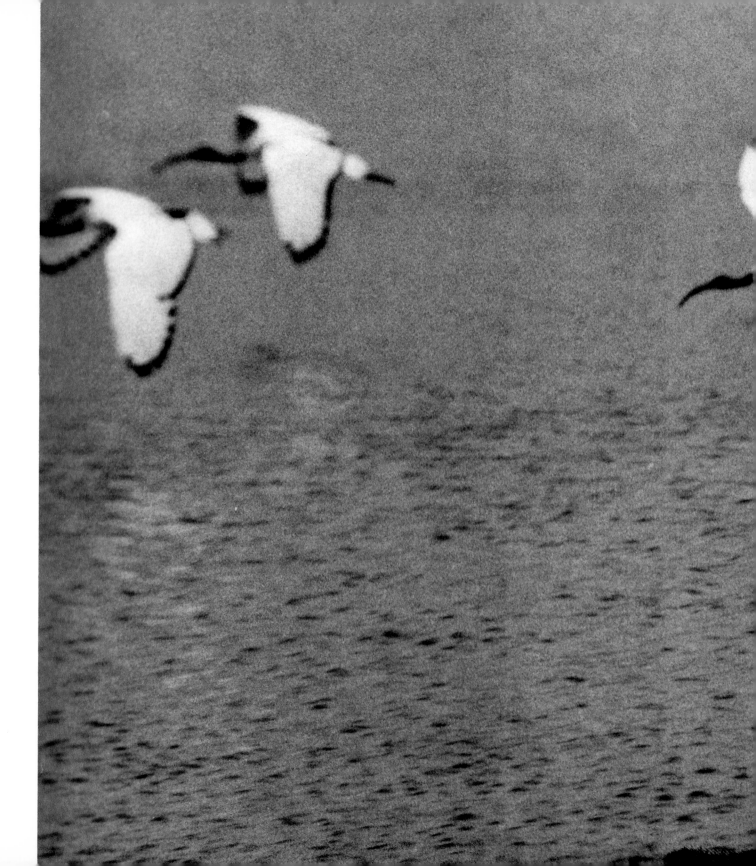

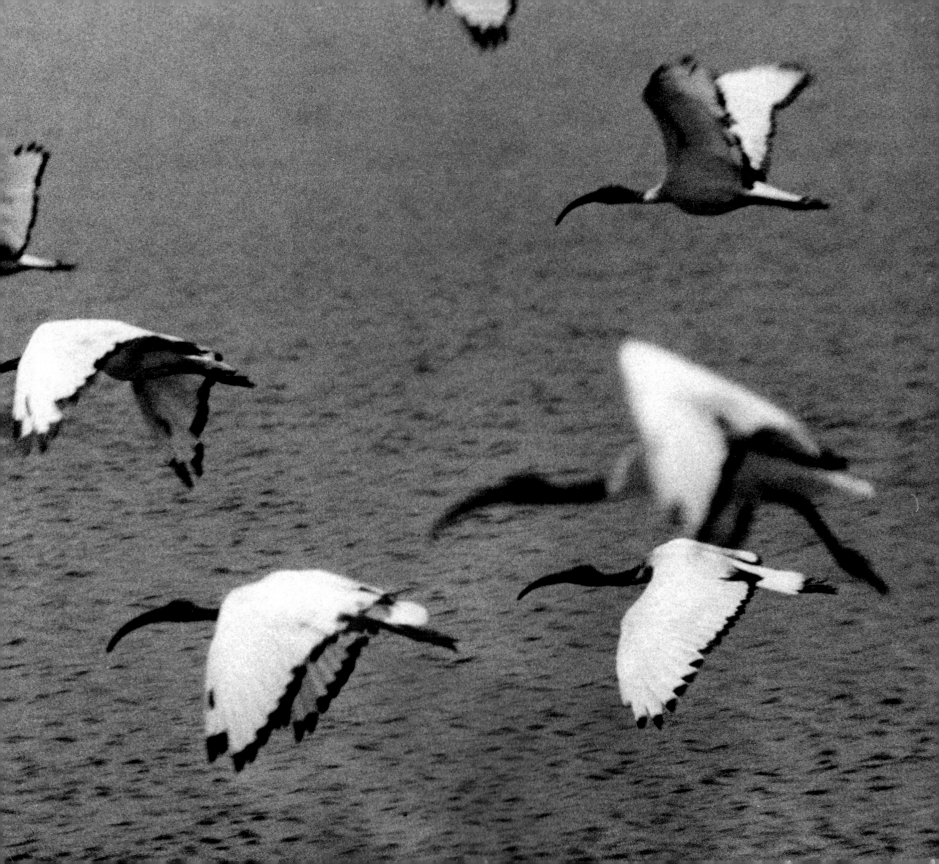

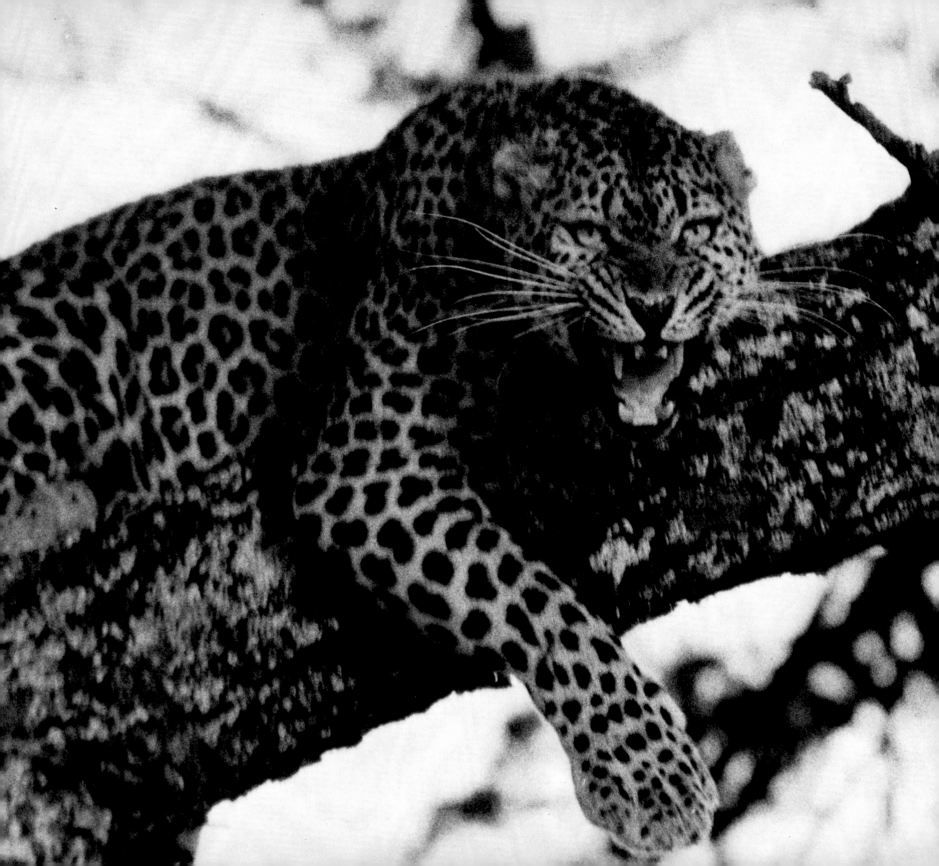

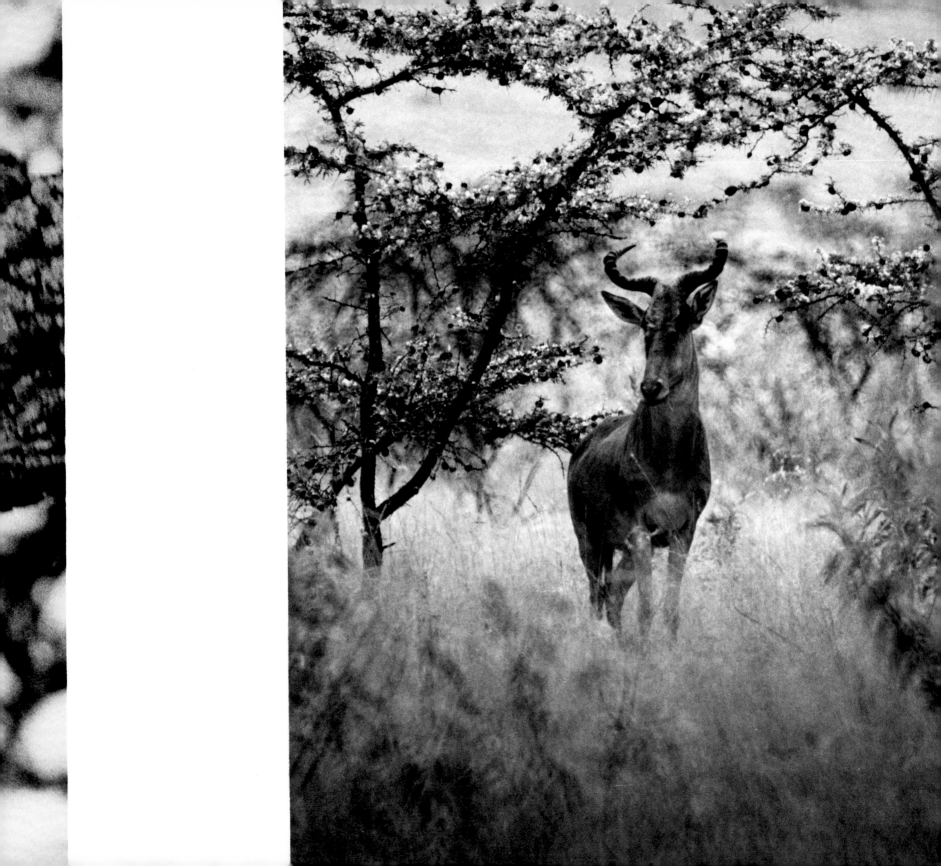

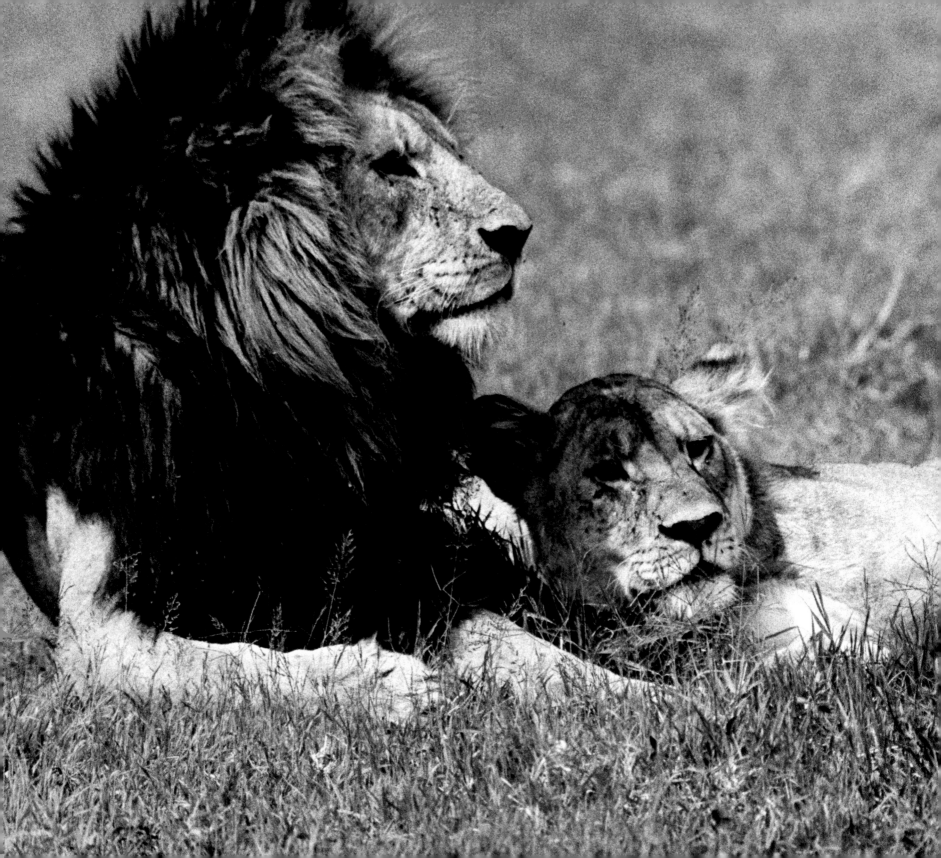

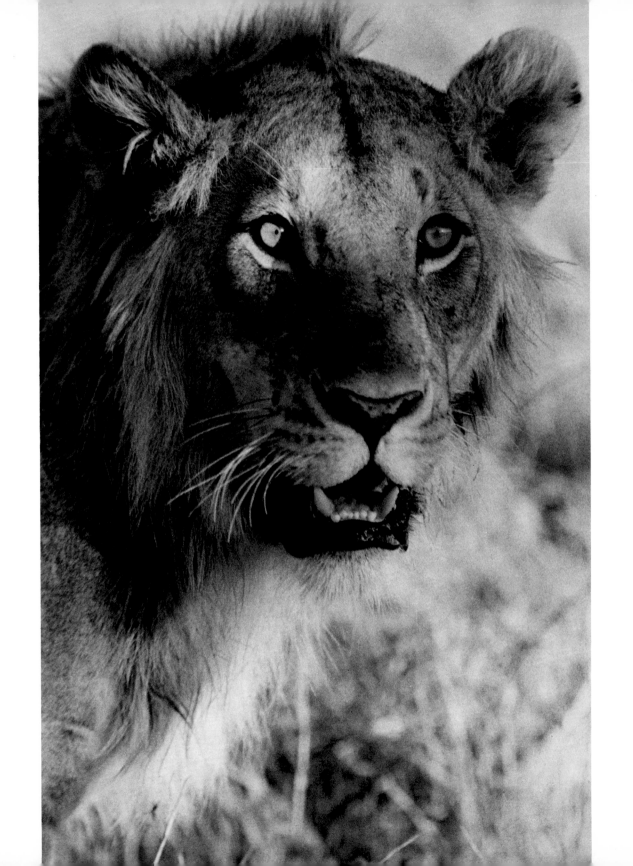

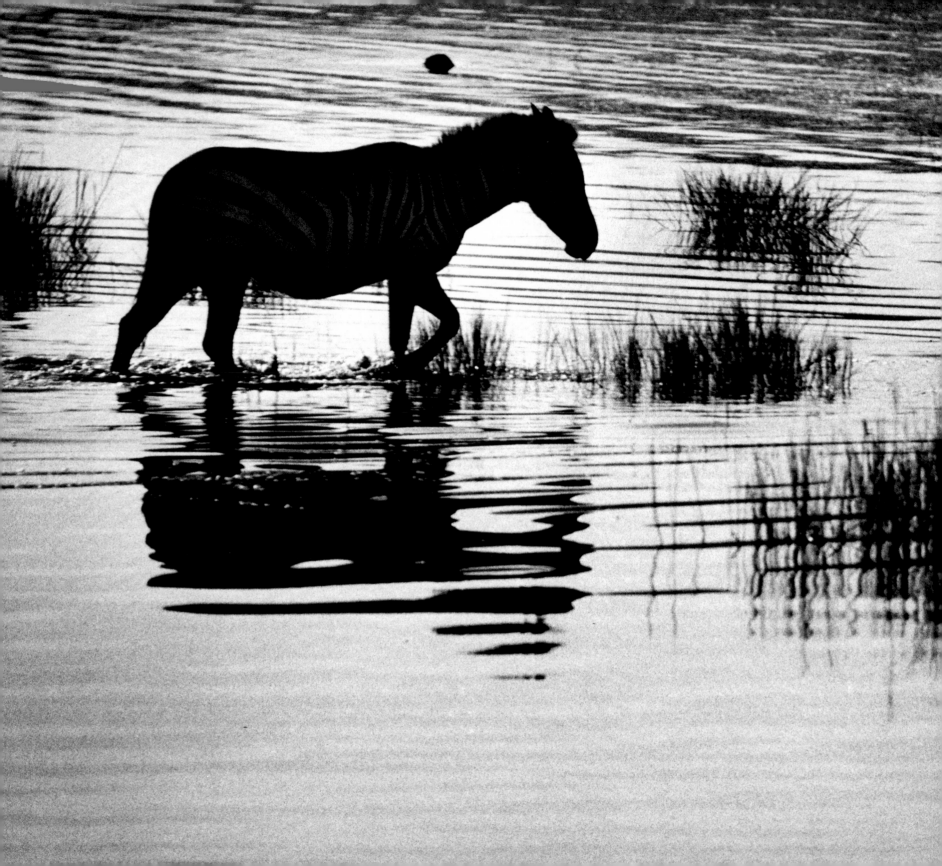

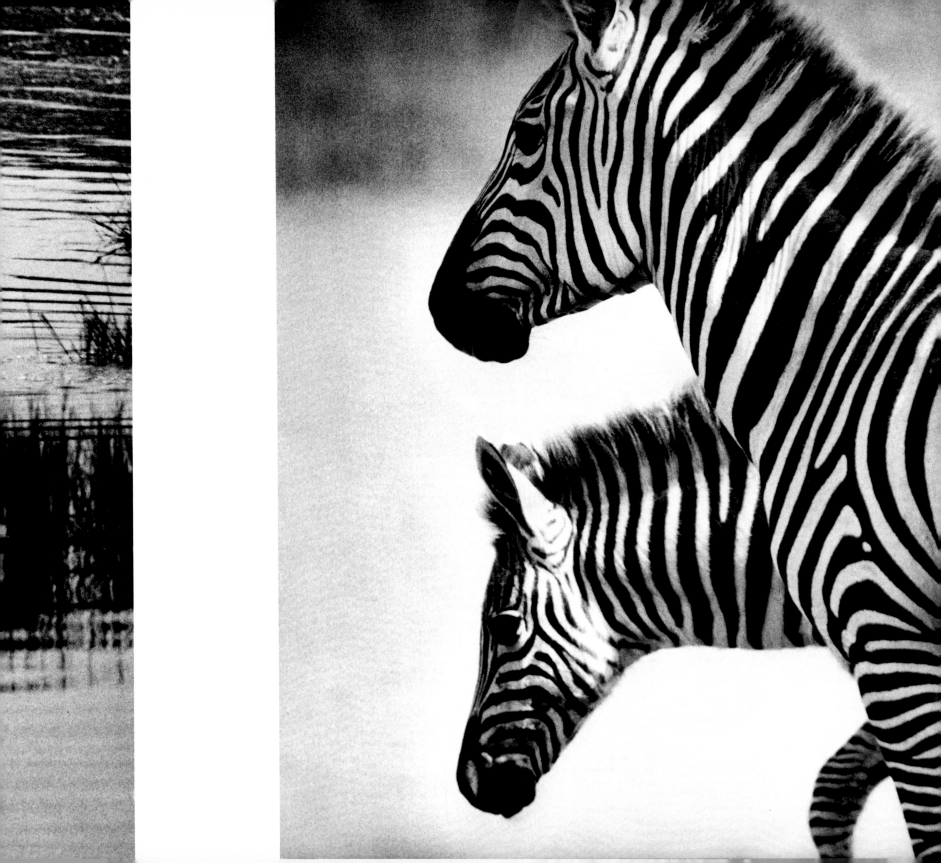

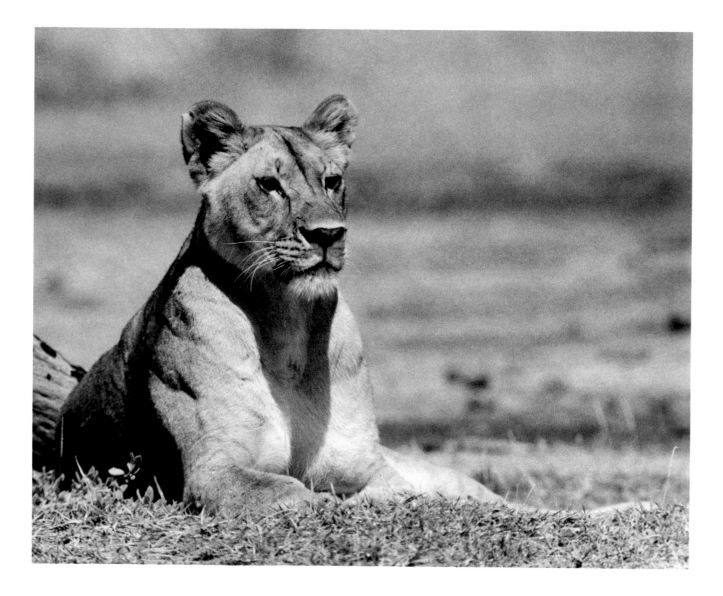

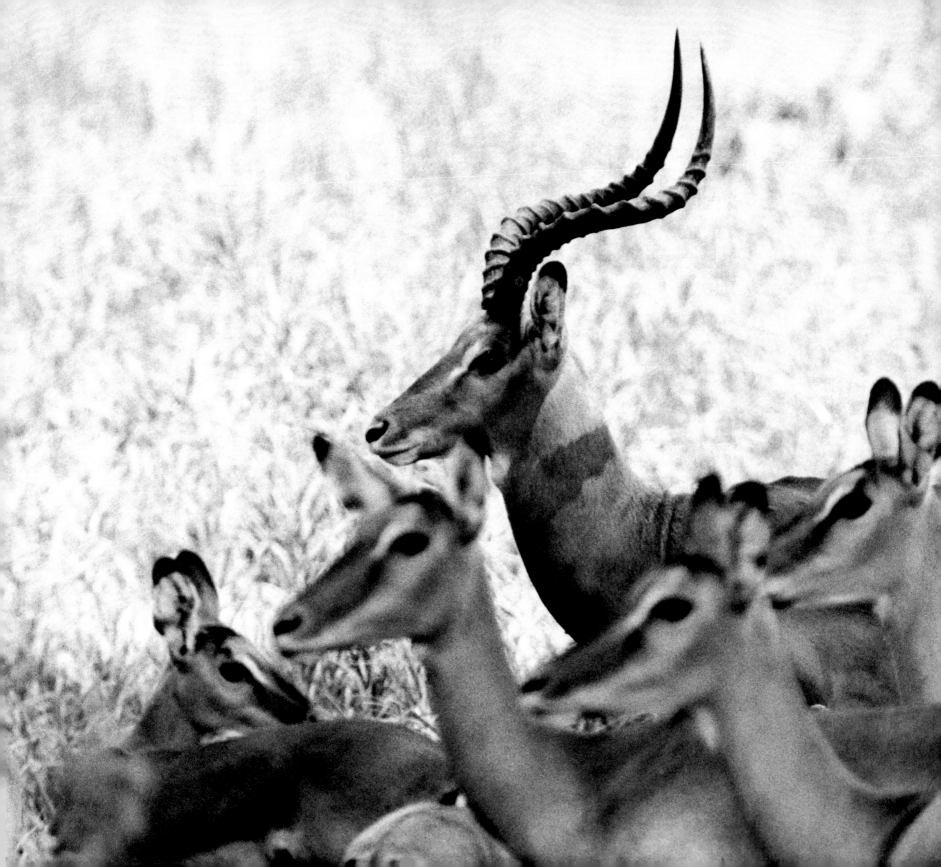

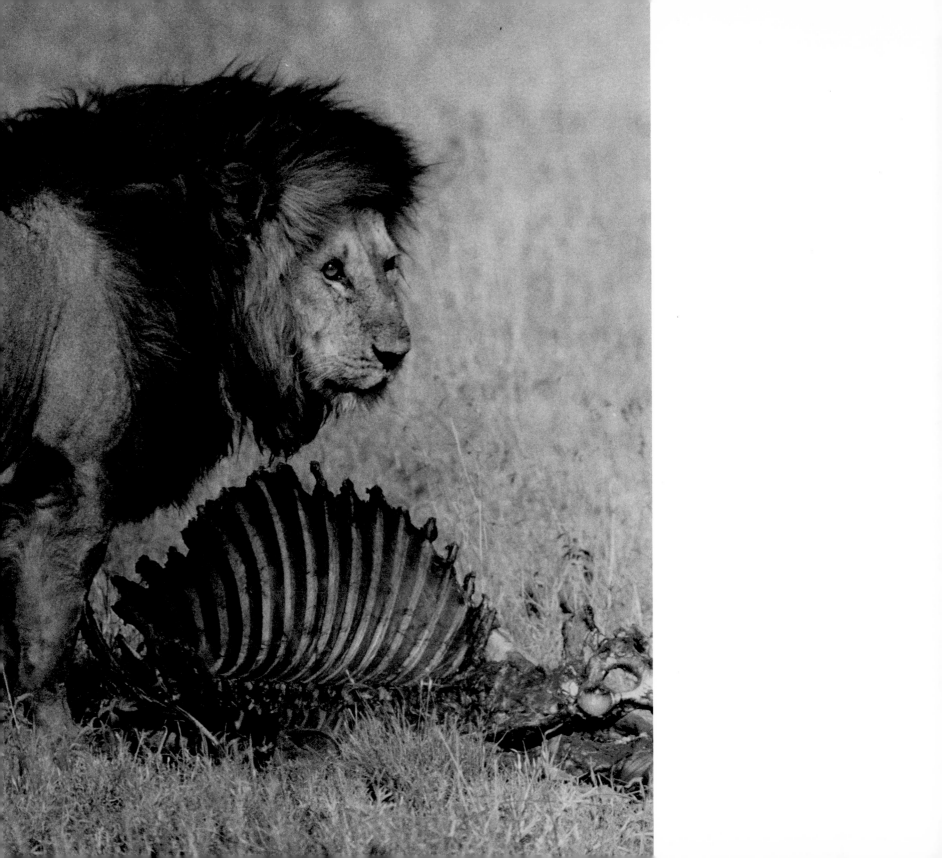

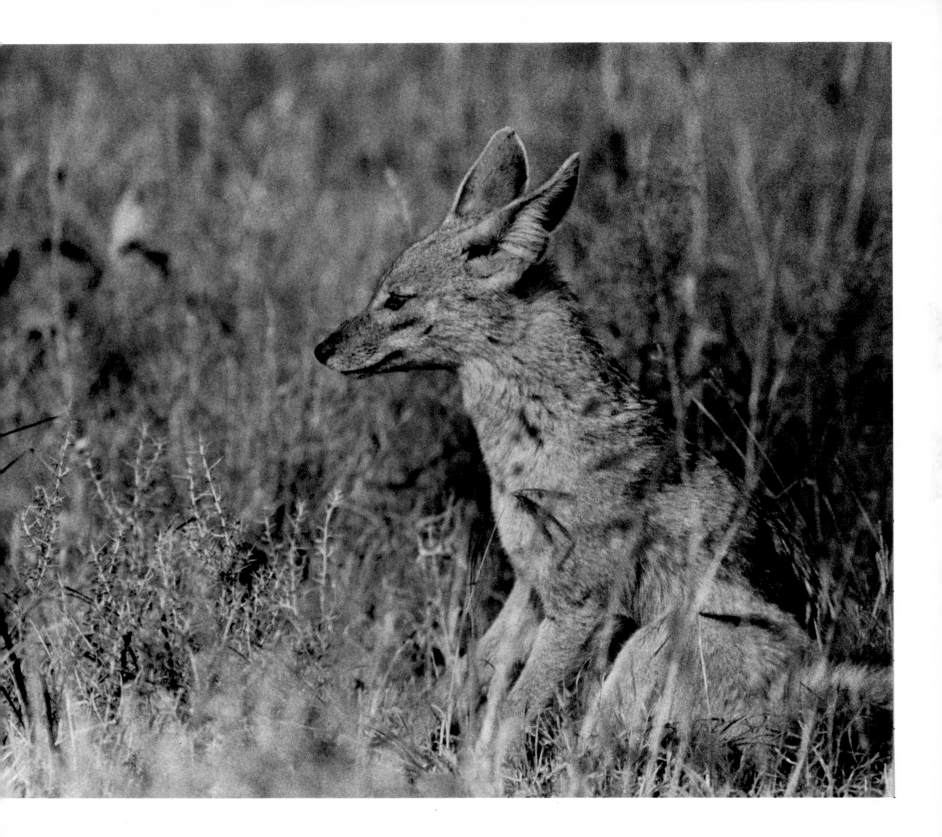

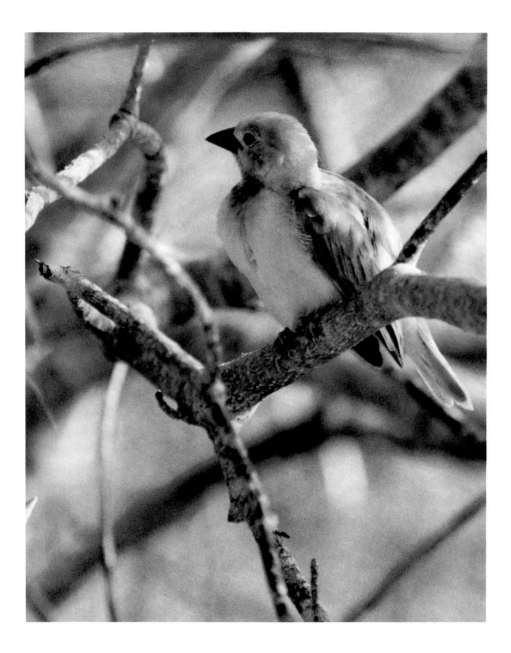

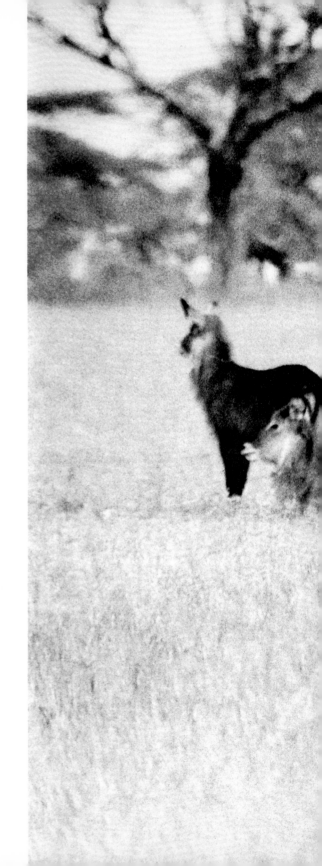

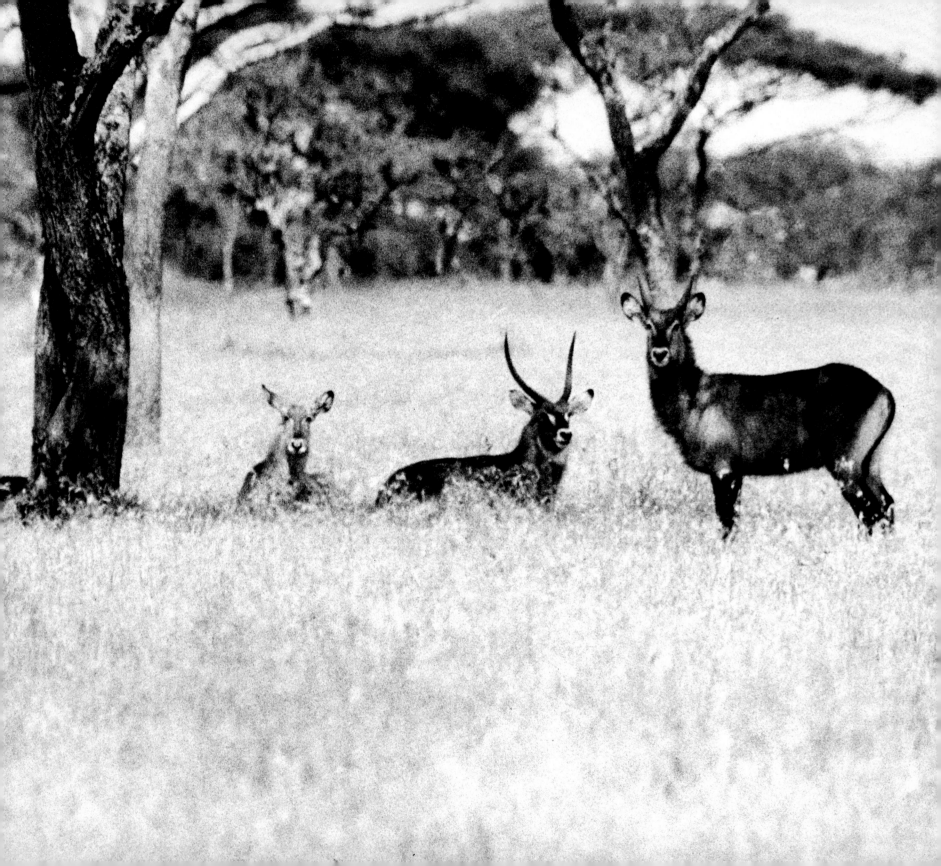

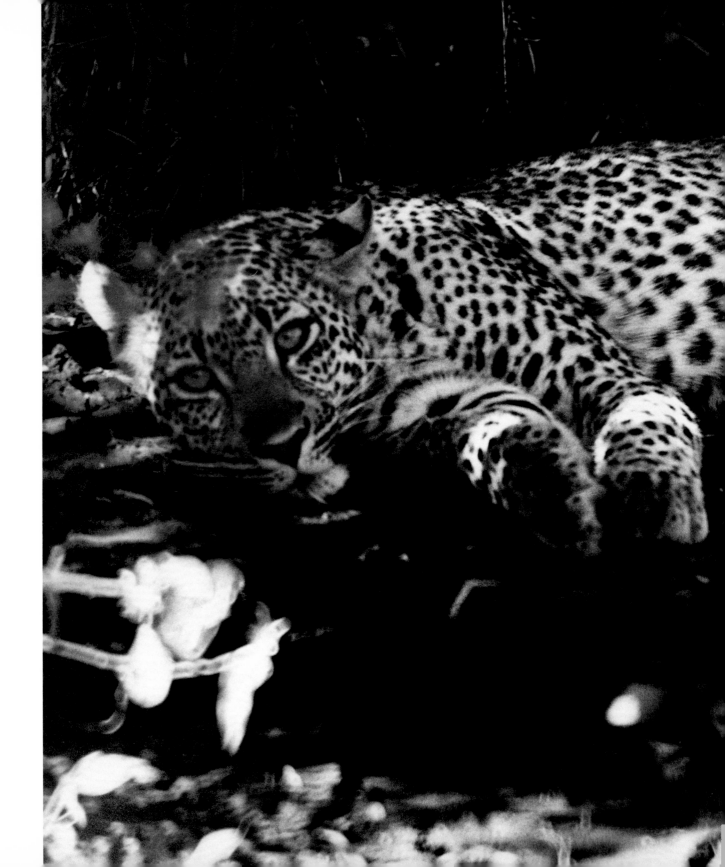

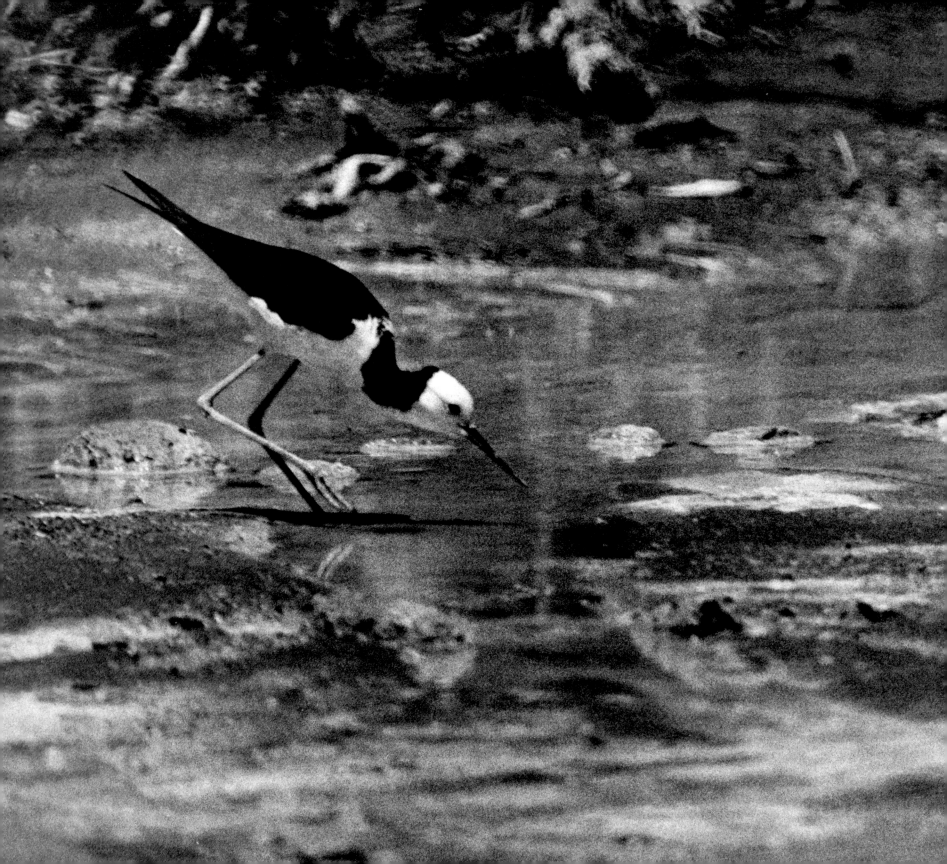

Another place that has always impressed me as a lovely natural place to live is New Zealand, with its mild temperate climate and rolling landscape, as yet relatively unspoiled by pollution, overindustrialization, and excessive urban crowding.

During most of the year the sea birds there are scattered over countless square miles of ocean and bay, except in the spring when hundreds of thousands return to their secret nesting places to lay their eggs and raise their young. During this season of bird concentration I decided to search out the royal albatross, the yellow-eyed penguin, the spotted shag, and the majestic gannet.

In Rotorua a pied stilt put on a strange display for my benefit. I was searching for birds' nests in the tall grass along the edge of a lake when I saw a flock of the long-legged birds fluttering about nervously on the nearby sulphur flats. Evidently the stilt I singled out in my finder had hidden its nest nearby in the deep grass because, to distract me, it began to limp in the opposite direction, dragging one wing. I thought it was injured until I realized that this broken-wing display was an effective method of distracting the bird's natural predators. The fact hit me when I looked up and saw the entire flock of stilts putting on the same broken-wing act.

Early one cool December morning a local ornithologist and I set out for remote Cape Kidnappers, a rocky peninsula on the east coast of New Zealand, the only mainland nesting grounds for that country's 60,000 gannets. The Land Rover bounced over mile after mile of dusty dirt roads through hilly sheep country before we finally climbed the last hillside to reach the Cape and its lonely beacon light. There, stretched before me jutting into the sea, was a plateau of rock, the nesting ground for thousands of these yellow-crowned sea birds.

The early hour offered my favorite low-angle lighting. It was just seven, and the sun

was still low on the horizon, backlighting each bird's black-tipped wing and tail against the morning sky. The wind chilled my bare hands as I frantically framed bird after bird in my ground-glass finder, tracking each one as he swept in from the sea, catching the updraft along the sheer cliffs and gracefully landing in the middle of the noisy colony to bring his mate some nesting seaweed and an affectionate greeting.

This greeting display of the gannets, so full of humanlike affection, is the same warm emotion I have seen demonstrated between lion and lioness, baboon and baby, buck and doe, and many other wild creatures.

A downy little black-backed gull chick was one of thousands I found hiding everywhere on rocky Somes Island. Colorful spotted eggs laid in well-formed nests in October had hatched some weeks later in the lovely New Zealand spring. Now screaming parents circled overhead, trying to frighten me away from their well-camouflaged chicks, but I managed to get some pictures despite the distraction.

Photographing a spotted shag on the Banks Peninsula made me aware of the risks a crazy wildlife photographer will take to get his shots. We had driven around narrow mountain roads and across open sheep meadows to reach a remote peninsula where we knew shags were raising their young. It was late in the afternoon, and as I looked over the edge of the sheer cliff, I saw that most of the nests were already in shadow. I decided to inch my way along the narrow ridge between the bay and the ocean to reach the only remaining well-lighted nests. Once I reached the end, I was too scared to stand upright any longer, so I lay down, my feet dangling over one side of the steep hill and my camera and telephoto lens peering over the edge of the cliff at the birds and the ocean below. I began to take my photographs, but every time a huge wave thundered in against the cliff the ground beneath me trembled and a chill of fear ran through me. What was I doing there? It was only after I saw the prints that I knew it was worth the risk.

The royal albatross, one of the largest of all flying birds, I found patiently sitting on a solitary fifteen-ounce egg, her ten-foot wingspan neatly tucked by her sides. A small colony at Taiaroa Head on the Otago Peninsula in New Zealand is believed to be the only mainland nesting ground of this beautiful sea bird. Here the albatross had taken up her long incubation vigil. Add to the two-month incubation period the seven months

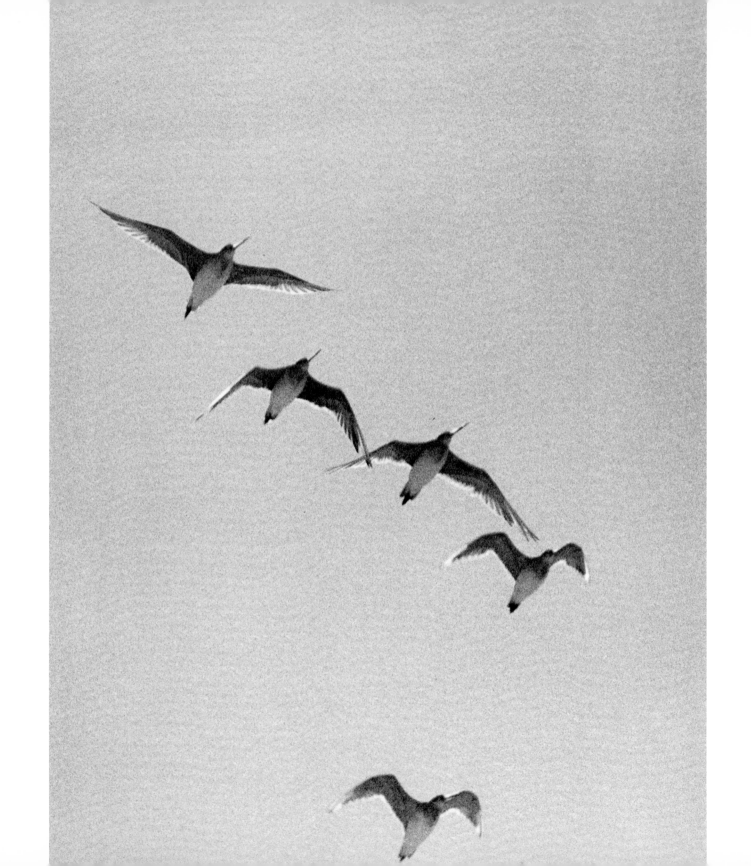

required to mature the young, and it's little wonder that the female albatross decides to lay an egg only once every two years.

Crossing the Foveaux Strait in New Zealand, I learned that the Cape pigeon, a member of the petrel family, was a very difficult subject for a portrait in flight. These sea birds are found all the way to Antarctica, although I found mine following the ferry as I crossed the strait. To photograph him, I positioned myself on the lowest deck and tried to focus on this fast-moving target as he quickly darted from one side of the boat to the other. He completely frustrated me until I decided to stop chasing him and let him come to me. I set my telephoto lens to 30 feet, tracked him in on each pass, and released the shutter the instant he came into sharp focus. It worked.

Thousands of godwits observed our arrival near a tidal sand bar off Stewart Island as we anchored our small fishing boat in the shallow bay. On the dunes we found an ancient Maori campsite littered with the bleached bones of seals, sharks, and aquatic birds. After a fascinating hour of picking up souvenirs of another age, we moved on to the sand bar, past half-buried skulls of stranded whales. It was soon apparent that it would be impossible to get close to the uneasy birds, so I decided to walk in quickly and raise the flock. As they passed close overhead, each small formation became a separate picture.

Wherever I have traveled to observe and photograph shags, pelicans, leopards, cheetahs, and other elegant forms of wildlife, I have become more and more aware of how man's uncontrolled increasing numbers and lust for profits are rapidly destroying the animal kingdom from which he evolved. Every day the very existence of these beautiful creatures, whose portraits I have taken, is threatened by thoughtless men. Each year animals and birds are being poisoned, shot out of the sky, run down by helicopters, snow sleds, and trucks by trophy hunters, clubbed for their hides, harpooned for their meat, plucked for their plumage, trapped for their fur, and left homeless by the relentless invasion of concrete. Most of this is overkill, unnecessary in our age of science and synthetics. There are substitutes available for the fur, the hides, the feathers, and the meat, yet men continue to steal from nature.

After many voyages out of man's city to take more than 7000 wildlife photographs, I

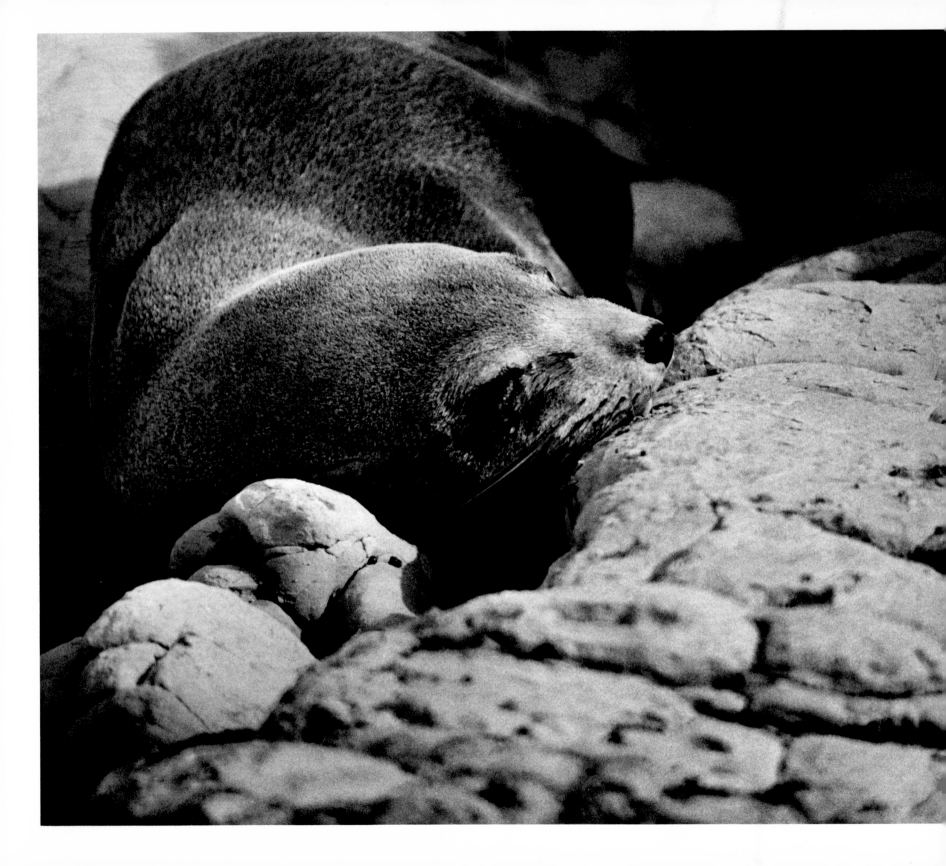

still consider myself an amateur photographer . . . but one who has acquired a conservationist's conscience. I find that I am not alone in this; there is a rapidly growing roster of new citizens of nature's world. People from many nations have used their cameras to bring them closer to nature. For many, nature photography has meant a change from their normal way of life. Several months a year during nesting season, a well-known dentist abandons his practice to earn his reputation as one of New Zealand's finest bird photographers. A busy Nairobi drugstore owner has won international acclaim for his creative nature photography. A retired business executive is one of the *National Geographic*'s skilled nature photographers.

This discovery of nature, whether it begins with wildlife photography, a kid's camping trip, bird watching, trout fishing, or shell collecting, brings with it an awareness of man's wanton destruction. Every true convert to nature soon becomes a part-time conservationist. Many of these nonprofessional conservationists are daily fighting important battles for all of us. They testify before Congressional committees; they address public gatherings; they publish and broadcast their message of concern.

Arthur Godfrey is such a man. An ardent worker for conservation, this busy man devotes a great deal of his time to learning more about our ecology and, more important, passing on to others what he has learned.

While I was still accumulating photographs for this book, I had an opportunity to show Arthur my collection of wildlife photographs from Africa. He knew every species, and he was filled with wildlife stories and with his change of heart about hunting. I asked him right then and there if he would agree to tell his story of how a hunter turned conservationist. He graciously consented to do so.

As for me, I never know where my curious eye will lead me next or what new, exciting adventures lie ahead. I only know I never again will be locked behind that executive desk picking my way through the "in-box"; no more wasted hours commuting daily to a dreary city office and no more boring conferences in smoke-filled board rooms.

Most of my precious time in the coming years I intend to spend in nature's world where I can watch the sun rise and set, listen to the cry of the gull, smell the salt sea spray, and savor all the sensory delights of each and every day.

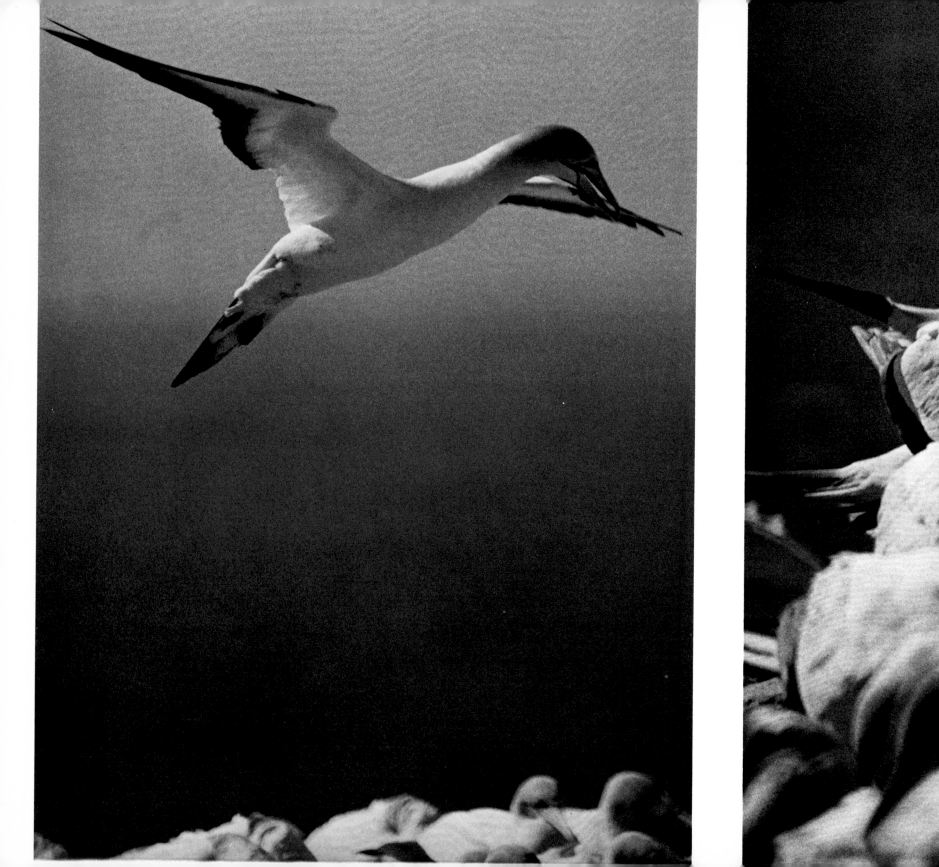

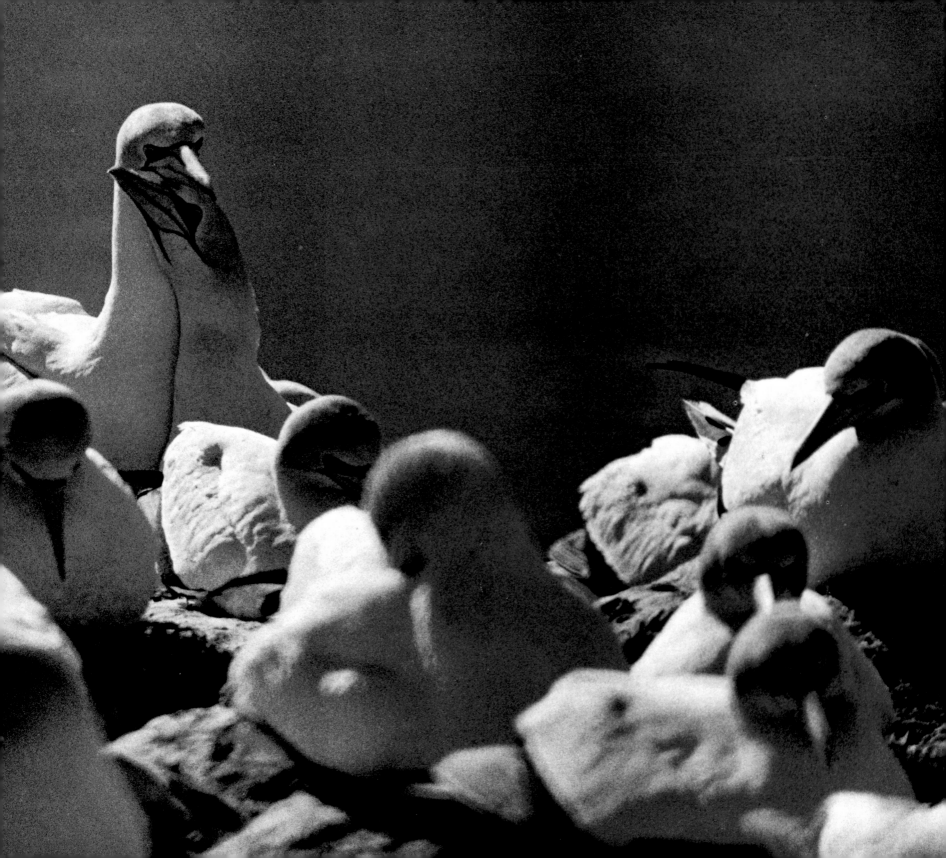

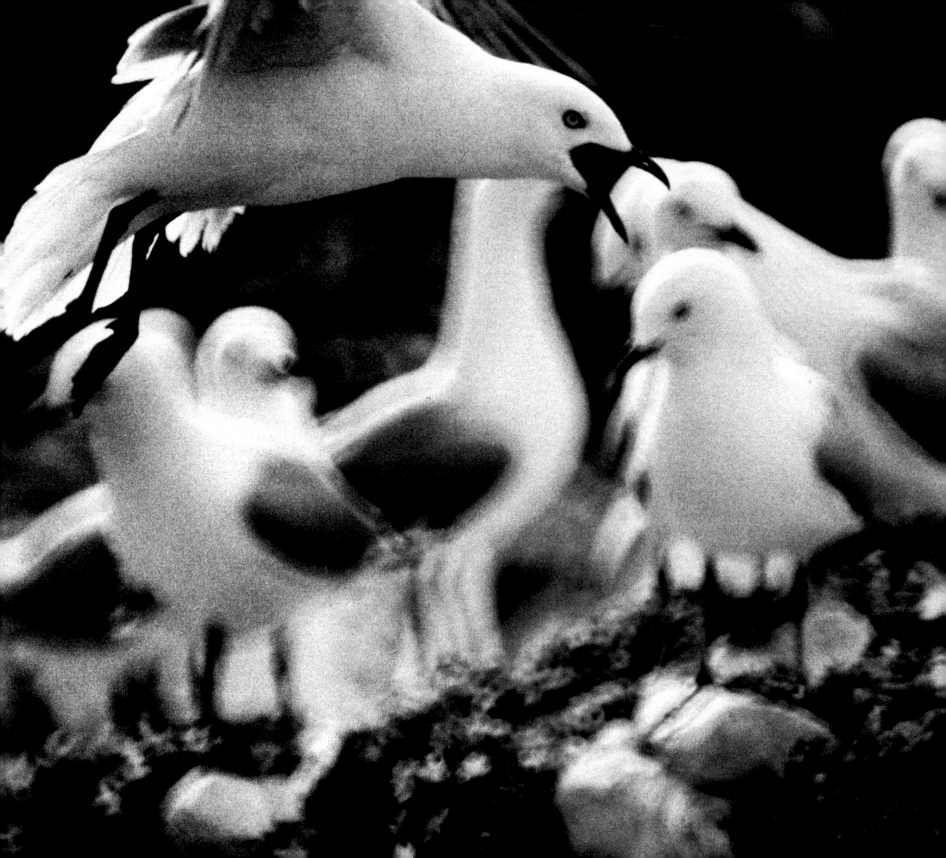

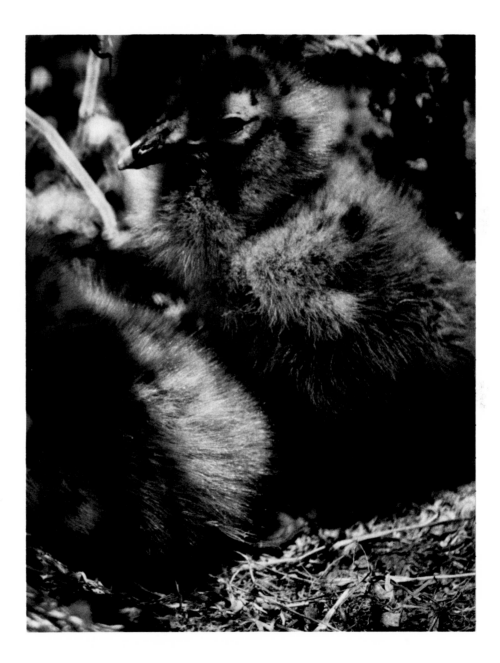

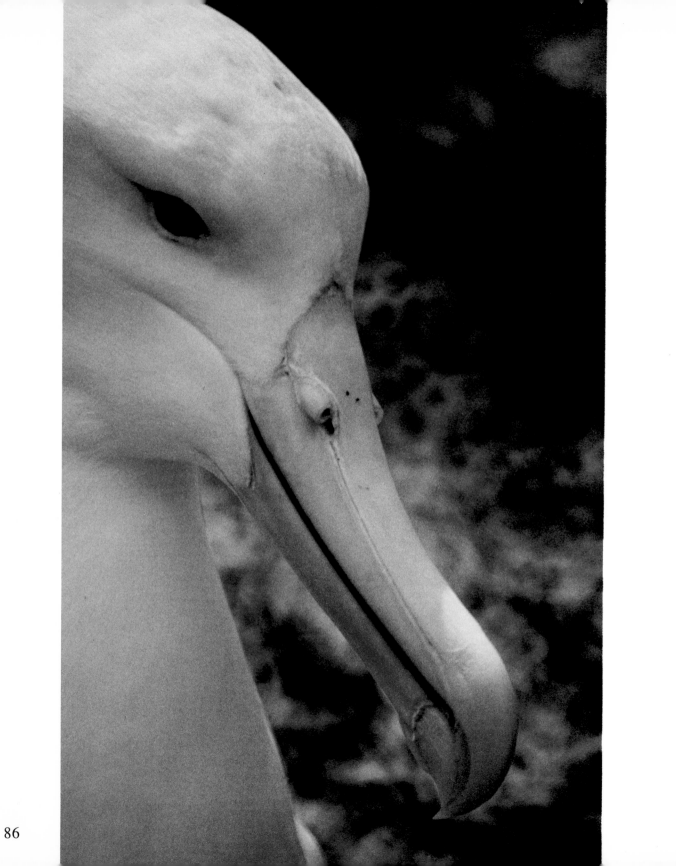

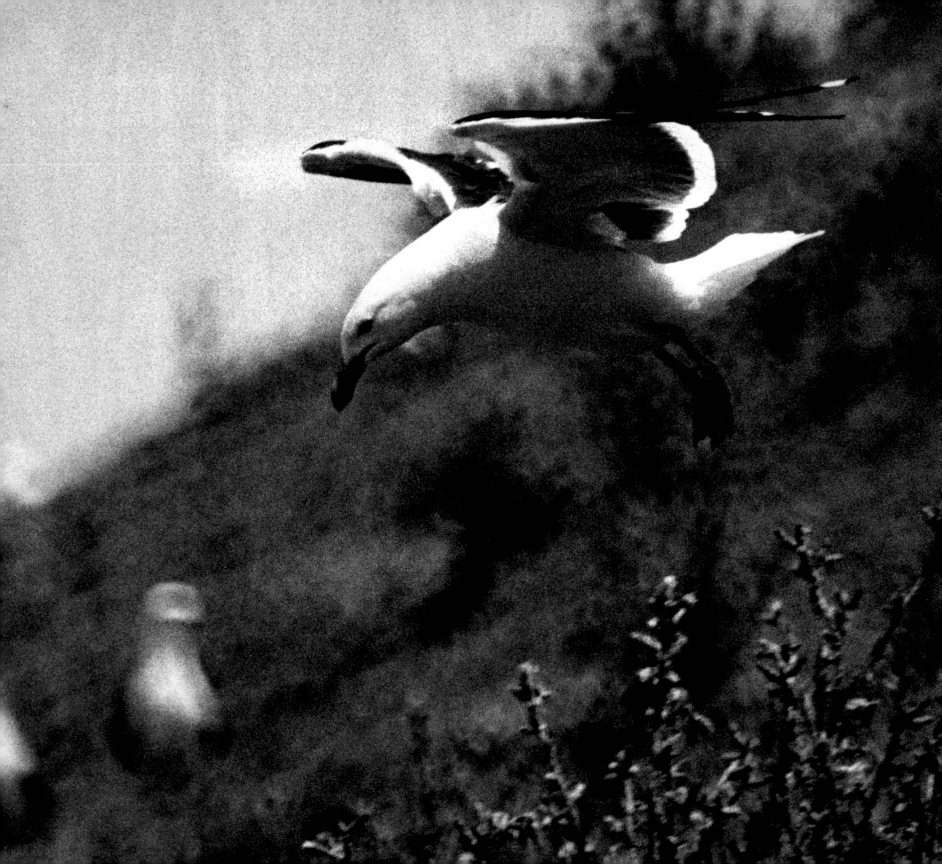

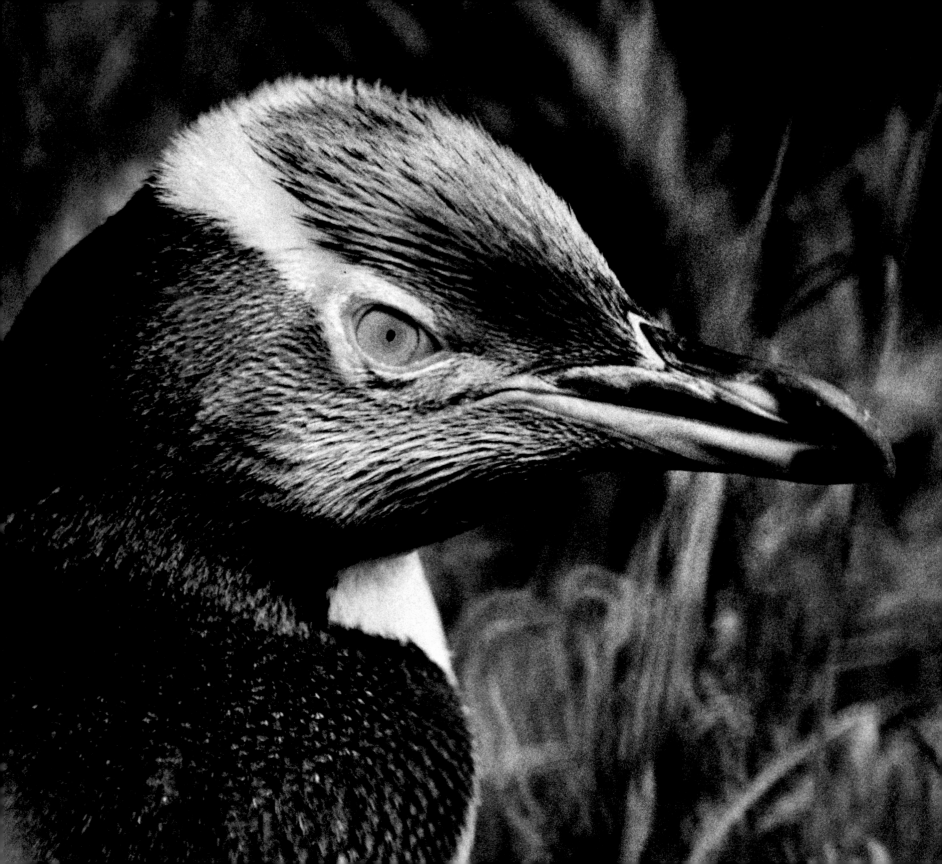

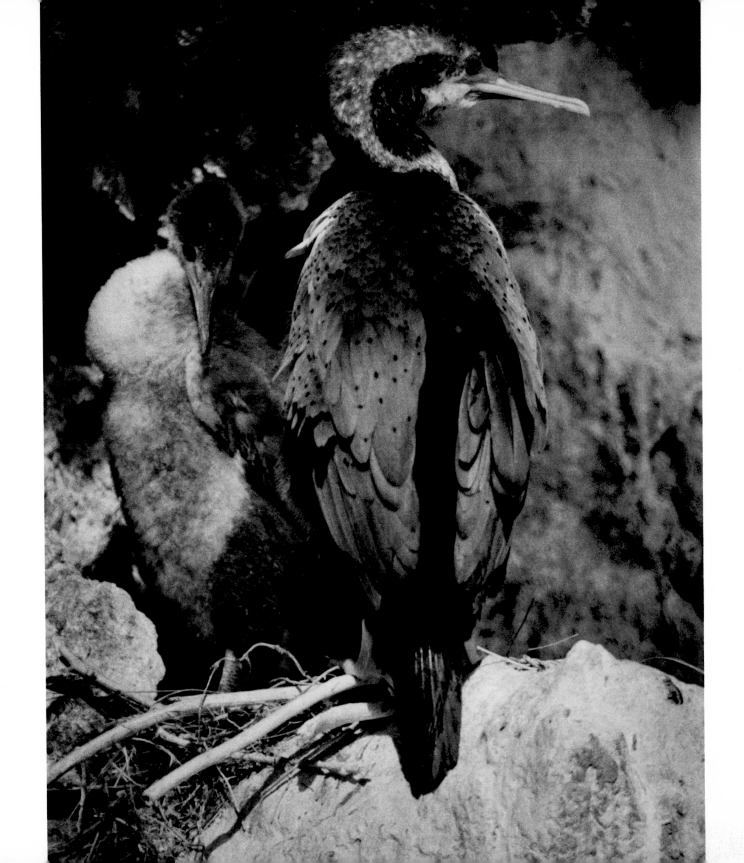

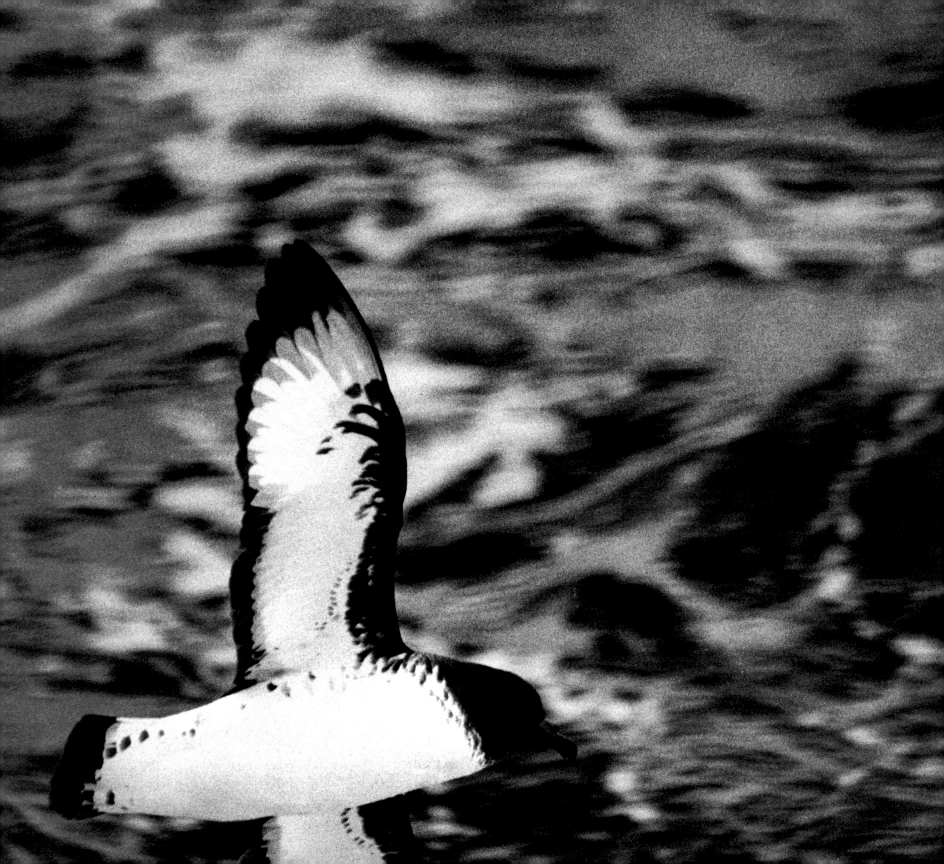

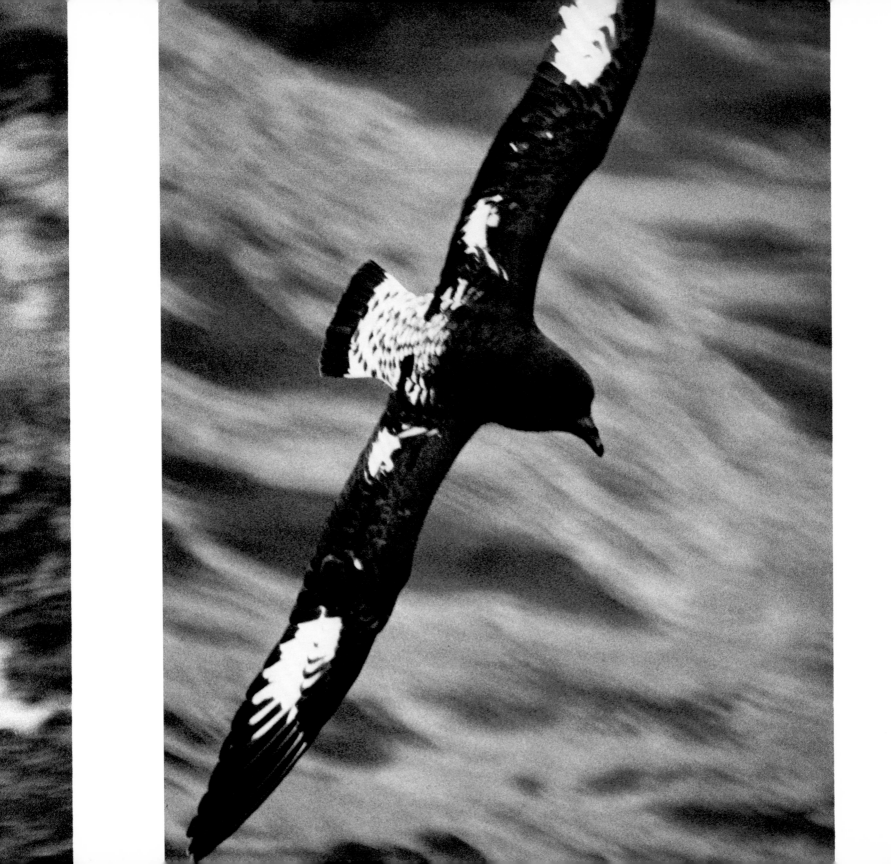

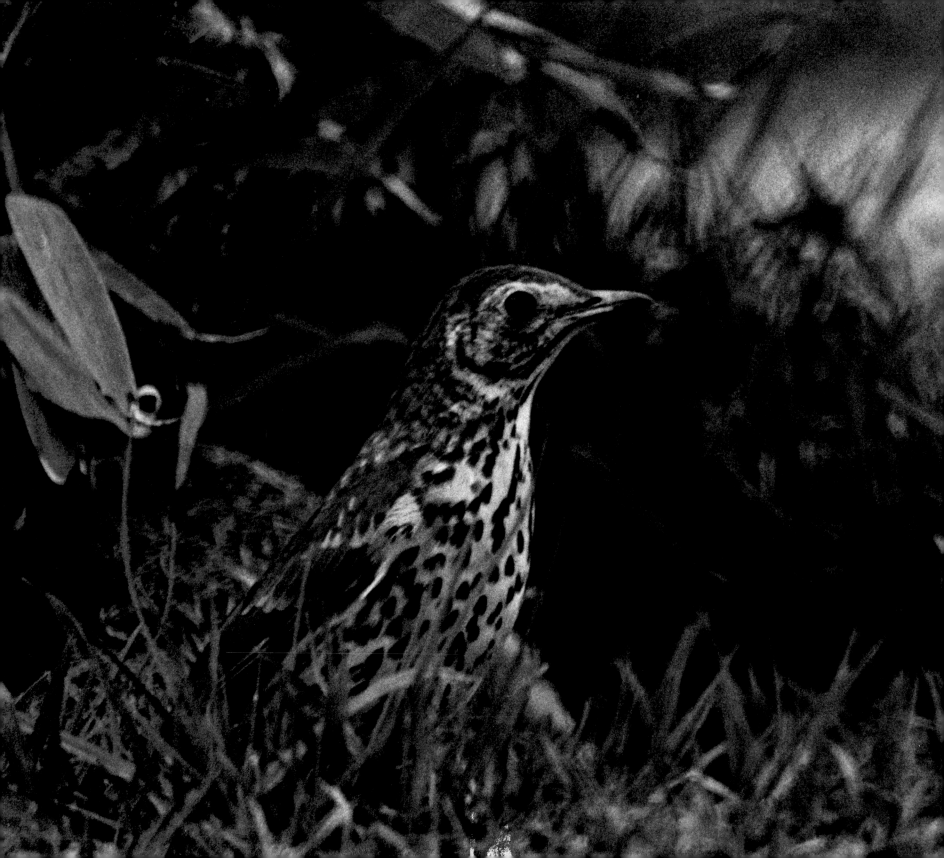

PHOTOGRAPHIC NOTES

Photography, like writing, is very personal. A photograph reflects the artist's interests and feelings. A serious photographer eventually develops his own subject area and his own style of photography. Most of the time I prefer to work in black-and-white and to use only natural light. For certain nature studies, where details of identification are needed, color film is a must. However, where I want to achieve a subtle mood in a wildlife study, I prefer black-and-white—in it, the elements of line, texture, and movement within the photograph are more apparent. Black-and-white doesn't have the same visual impact as color, but it does convey fact and feeling.

There are many fine cameras available today for someone intent on wildlife studies, but my comments here will be limited to identifying the equipment I presently use.

Travel is always rough on delicate instruments, so when I'm on the move, my camera equipment is packed in a fitted aluminum case which is easy to put under an airline seat, where it is safe from careless baggage handlers. Each piece of equipment is registered with the Customs office at the airport before departure, to avoid embarrassing arguments about import duty when I return from overseas.

I never want to get stuck in the wilderness with a broken camera, so I always carry two camera bodies. Both of the cameras are 35mm single-lens reflex, equipped with a motor drive. Having two cameras facilitates photographing each subject interchangeably in color and black-and-white without reloading, and the motor drive makes it possible to take a rapid sequence of frames of swiftly moving birds or animals.

For a long trip my minimum selection of equipment includes a Macro lens, a wide-angle lens, a 500mm telephoto, a 1600mm telephoto . . . plus a full set of filters. My present selection includes a Micro-Nikkor Auto, 1:3.5 f-55mm, a Nikkor-N Auto 1:2.8 f-24mm, a Reflex-Nikkor 1:8 f-500mm, and a Questar.

A limited selection of 35mm film is usually available at camera stores in most countries, but to avoid disappointment I take along the two specific films I prefer. To prevent it from being damaged by X-ray or electronic equipment operated to screen luggage, I always carry the film with me to my seat.

Tri-X, which I prefer for black-and-white wildlife photography, has an ASA rating of 400 but can be exposed as though the rating were 1800, then pushed in the developing to compensate for the underexposure. This makes it possible to use much higher shutter speeds with the slow reflex telephoto lenses. A gratifying characteristic of this fast film is

its ultrafine grain. Excellent 11″ x 14″ enlargements can be produced from Tri-X negatives, with the possibility of much larger exhibition prints.

When the Tri-X is developed and printed on a single contact sheet, a selection of the better negatives can be made and the best ones singled out for 5″ x 7″ glossy proof enlargements. After a more detailed inspection of this larger print, exact cropping for a salon print is indicated with a red china-marker. My preference for the final enlargement is rich brown-black Indiatone paper, flush-mounted on double-weight board for ease of handling and attractive presentation. On the average, I require a selection of 36 black-and-white negatives to find one worthy of a salon print. Things happen too fast in wildlife photography to get a sharp negative and a studied composition on each frame.

High Speed Ektrachrome, specially developed for an ASA of 400, is my preference in a color film for wildlife telephoto shots. Selection of color transparencies is just as ruthless as for black-and-white. From the 36 transparencies developed, only a few slides may be exhibited.

When the slides are first developed, I put them all on a light box and scan them simultaneously to select the best of each sequence. At this stage half of the transparencies are scrapped. The next step is large-screen projection. Here the selection process continues, and as few as six slides may be selected for exhibition while any possible "keepers" are filed away for future reference. Any improvement of composition in an individual slide is made by rephotographing that slide on a Repronar—a vertically mounted 35mm camera with electronic flash assembly specifically designed for this purpose.

Several years of combing my own negatives for successes and failures have taught me a few helpful things about getting good pictures:

Photograph when the sun is low. Long shadows add a three-dimensional quality to wildlife photographs. For black-and-white photography in sunlight, the hours from dawn to about ten in the morning and from three in the afternoon to sunset produce the best effects.

Backlight the subject. Approaching the subject with the sun in front of the camera or just slightly to one side often produces the more interesting lighting effect. In black-and-white photography flat lighting on either the subject or background usually produces a flat, lifeless image.

Frame the subject. It is often effective to frame the subject through a foreground of tall grass, hanging leaves, or dead tree limbs. An out-of-focus foreground can add depth and dimension to the final composition.

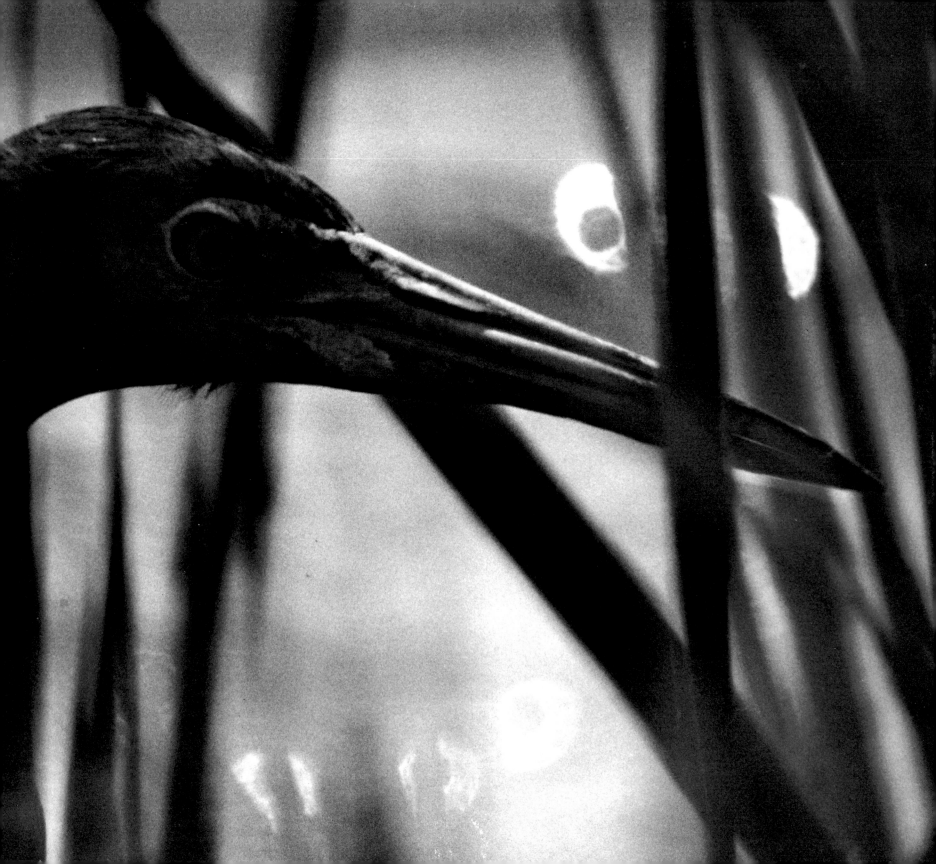

ILLUSTRATIONS